# THE PRINT AND DRAWING COLLECTION
## JUDAH L. MAGNES MUSEUM

Florence B. Helzel

WITHDRAWN

Judah L. Magnes Museum
*The Jewish Museum of the West*
Berkeley, California

Library of Congress
Catalog Card Number
84-80379

ISBN No. 0 943376-24-6

# CONTENTS

*To Leo B. Helzel*

# F O R E W O R D

*by Seymour Fromer, Director*

We are doubly indebted to Florence Helzel for this catalog of the print and drawing collection of the Magnes Museum. First, it demonstrates one of the achievements of the first two decades of the Magnes Museum — the assembling through gift and purchase of a truly impressive and wide ranging collection of graphic art. Second, the catalog reflects the fact that many people gave of their possessions and substance to provide for a public collection of Jewish art. A public collection must be a resource for scholars, artists, and visual communicators as well as for temporary or traveling exhibitions.

A museum is the place where the collection, the curator, and the public meet. Thus this comprehensive catalog also makes us aware that the formation of a significant collection is but the first step in the Museum's primary task of conservation, research, and exhibition of work that reflects the Jewish experience over the past 150 years.

The catalog and coordinating exhibition, "The Jewish Experience in Prints and Drawings — The Magnes Collection," held at the Museum from February 12 to May 13, 1984, present sixty-three works of art on paper by artists from Europe, Israel, and the United States. These prints and drawings reveal a richness of art and history. We can look forward with anticipation as the curators and librarians of the Museum continue the model of this and previous catalogs in making accessible and interpreting the treasures of Jewish art housed in Berkeley.

# P R E F A C E

This catalog is an overview of the graphic art collection of the Judah L. Magnes Museum. The collection focuses on Jewish life and history and contains over two thousand prints and drawings, mainly by Jewish artists.

Since 1962, the year of the Museum's founding, the Magnes has collected prints and drawings. In those twenty-two years, only a small portion of the graphic art was researched and cataloged. In fall 1981, the Museum made a strong commitment to the maintenance and development of the collection and established the graphic art department in its own quarters. A professional condition and conservation survey of a substantial number of works was completed in 1983.

Gifts of art and donations to purchase prints and drawings have formed the collection. It is because of the generosity of the Museum's benefactors that quality works of art on paper continue to add to the Museum's holdings.

The catalog would not have been produced without the talented assistance of many people. My special gratitude goes to Deborah Kirshman, program coordinator, Center for Museum Studies, John F. Kennedy University, for serving as the catalog's editor; Robert Futernick, conservator-in-charge, Western Regional Paper Conservation Laboratory, San Francisco, for his invaluable assessment of the collection; Trisha Garlock, founding director, World Print Council, for her aid in paper analysis; Sharon Deveaux, photographer, for her splendid illustrations; and Ted Cohen, exhibition designer, The Oakland Museum, for his special generosity. I am also indebted to Seymour Fromer, director, and Ruth Eis, curator, Magnes Museum, for their support and enthusiasm. Sincerest thanks are extended as well to the staff of the Museum for all their help, especially Alice Perlman, assistant curator, Ted Greenberg, registrar, and Malka Weitman, public relations director.

F. B. H.

# INTRODUCTION

*by Florence B. Helzel, Assistant Curator*

The graphic art collection of the Magnes Museum consists of a wide range of media — etchings, engravings, woodcuts, lithographs, screenprints, watercolors, and drawings. Together these works provide a visual documentation of Jewish culture and history from the eighteenth century to the present. The collection also demonstrates the significant contributions Jewish artists have made to printmaking as an important vehicle for artistic expression.

The secular and spiritual sides of Judaism have provided topics for artists throughout the centuries. Subject matter including Jewish history, portraiture, the Bible, Jerusalem, rabbis and scholars, synagogues, the shtetl and ghetto, and Jewish genre and ceremonial life are represented in the earliest dated works and in the most contemporary art in the collection.

In the early nineteenth century Moritz Oppenheim was one of the first Jewish artists to depict Jewish themes. In a style that mixed genre with the historical, Oppenheim chronicled German Jewish life. Later, during the early twentieth century, Hermann Struck continued the genre tradition with etchings and lithographs of the shtetl in Eastern Europe. Jewish life in New York's Lower East Side is portrayed in the etchings by William Auerbach-Levy and in drawings by Abraham Walkowitz.

Scenes of Palestine's early twentieth-century history are depicted by Jakob Nussbaum, Ephraim Lilien, and Bernard Zakheim. Jewish history is documented as well in Max Pollak's etchings of Jewish refugees in Camp Nikolsburg, Czechoslovakia. These works are a poignant reminder of the plight of displaced persons during World War I.

During the first decades of the twentieth century, ceremonial life was a prevalent theme in the oeuvre of Hermann Struck, Jakob Steinhardt, Lionel Reiss, and Peter Krasnow. These artists reaffirmed ancient rituals and traditions through their etchings and lithographs.

Since the 1940s a most important influence on Jewish artists' work has been the Holocaust. Many artists, whose work previously had reflected their assimilation into the mainstream of their native or adopted countries, experienced a heightened Jewish consciousness and turned to Jewish themes to express their outrage and compassion. Harold Paris recorded the horror he witnessed in Buchenwald in 1945 with a series of woodcuts made almost twenty years later. The social realist and cartoonist William Gropper turned to Jewish subject matter after visiting the ruins of the Warsaw Ghetto in 1948.

Jewish iconography since the Second World War does include many other themes besides the Holocaust. Artists often express hope, joy, and humor in their work. Chaim Gross' and Marc Chagall's Chasidic upbringing in Russia is reflected in their lithographs. Many of Gross' prints express the tenderness and happiness of parental love. Much of Chagall's brilliantly colored work combines reminiscences of the shtetl with his favorite and familiar imagery of lovers, birds, and flowers. Abraham Rattner's abstract lithographs of Israeli landscapes, with their glorious color and vitality, evoke a positive emotional response to the timeless quality of *Eretz* Israel.

*Artists as Printmakers*

Among the artists represented in the Magnes collection are those *peintre-graveurs* who have made printmaking an integral part of their oeuvre, not merely an adjunct to it. These artists, most of whom were born in Central or Eastern Europe, immigrated to Palestine, Paris, or the United States.

Master printmakers Hermann Struck and Ephraim Lilien inspired many European Jewish graphic artists. Struck received his greatest recognition with his etchings and in 1909 published *Die Kunst der Radierung* (The Art of Etching). These artists, along with Jakob Steinhardt and Abel Pann, brought their enthusiasm and expertise to Palestine in the 1920s and 1930s. Steinhardt produced distinctive etchings while working with used metal plates and makeshift equipment. His greatest artistic achievement, however, is his woodcuts. He perfected a technique that combined large areas of black and white with the detail lines of wood engraving. Abel Pann furthered printmaking in Palestine by creating the first colored lithographs in 1925. During the 1940s Isidore Aschheim was one of the few artists producing etchings and lithographs and was mainly responsible for teaching printmaking techniques to the new generation of Israeli artists.

Lured by the avant-garde art movements, some Jewish artists settled in Paris during the first decades of the twentieth century. These artists became part of the Jewish School of Paris and produced prodigious amounts of graphic work as well as oil paintings. Encouraged and commissioned by eminent publishers such as Ambroise Vollard, Chagall illustrated the Bible and books by Nikolai Gogol and Jean de la Fontaine. The painters Louis Marcoussis and Moise Kisling produced etchings in their respective cubist and romantic styles.

During the mid-twentieth century, native-born and immigrant Jewish painters and sculptors produced innovative graphic works in the United States. Irving Amen, Leonard Baskin, and Raphael Soyer made printmaking a continuous part of their art. Amen is acknowledged as a leader of the brilliant and vigorous revival of the color woodcut during the 1940s and 1950s. During the 1950s as well, Baskin began a series of woodcuts gigantic in scale and perplexing in imagery, such as *Man of Peace*. Over a period of sixty-five years, Soyer has produced a vast body of graphic work as well as paintings. In 1917 he started etching, and in the 1920s he began lithography. Soyer's prints are sometimes preliminary studies for a painting or a sequel to a painting already completed.

The advancement of technology during the 1970s and 1980s has given artists the opportunity to experiment with many new techniques for printmaking. For example, the work of California artist Stephanie Weber has evolved from traditional etching to mixed media art that combines etching with xerography, painting, and drawing. Future technology will enable artists to create inventive, complex, and highly imaginative graphic art. It is hoped, however, that Jewish artists working with the new processes will continue to express their heritage and Jewish consciousness, thereby imbuing their art with special meaning and distinction.

# REFLECTIONS ON THE PRINT AND DRAWING COLLECTION

*by Ruth Eis, Curator*

The Judah Magnes Museum's print and drawing collection, which spans approximately the last 150 years, provides a tool for better understanding the role played by Jewish artists the past two centuries. Prior to the Age of Emancipation in the late eighteenth century, the art of the scribe, the engraver, and the portraitist flourished among Jews. At the core of this art there was always a utilitarian *raison d'etre* — for example, to write texts for educational purposes, to illustrate books for better explication, and to record the lives and visages of personalities. In a Jewish society that accepted as the only "breadless" occupation the study of the scriptures, a society that equated beauty with holiness, no room existed for the pursuit of nonutilitarian engagement. It was perhaps this fact that prompted the historian Tacitus to remark "among the Jews all things are profane that we hold sacred" — an observation that surely reflected in part the Jewish attitude toward the fine arts.

After the Age of Emancipation, Jewish artists began to work in the fine arts while they continued their artisan and craft traditions. Notable in the Magnes collection are the drawings of Moritz Oppenheim. His work illustrates the transition made by Jewish artists from producing functional art to art that was made solely for the enjoyment of the viewer. Oppenheim's oeuvre paved the way for artists born toward the late nineteenth century.

In the early twentieth century Jewish artists in Eastern and Western Europe were drawn to a variety of subject matter. In Eastern Europe artists sustained a spirit of tradition by selecting scenes of the ghetto, houses of prayer, and life in exile. Their newly assimilated counterparts in Western Europe preferred landscapes and genre scenes. These artists were romantics who had not yet grasped the new freedom. By the second decade of the twentieth century, their time had come; they abandoned academic tradition to express in their work their own hopes, fears, and fantasies. Perhaps tendencies had already been present for this new expression: preoccupation with the inner self, intellectualism, and the parallelism of the Jew as outsider with the artist's isolation in society. By the 1930s in America artists expressed themes of social awareness, as evidenced in the prints and drawings of Ben Shahn; from the 1940s on many artists have repeatedly illustrated the Holocaust.

A large number of the prints in the Magnes collection were produced by young European artists who arrived in Palestine in the mid-1920s. In the new land they were isolated from the mainstreams of art. The fact that these artists succeeded in creating a unique style that drew from their past and mingled with the oriental suggests the idea that artistic genius thrives in isolation, where the only difficulty is in finding the right balance

between the need for the nurturing traditions of the outside world and the demands for self-exploration. Similarly, those artists who immigrated to the United States and were removed from their European milieu were in a position to advance new ideas and give free rein to their inventiveness.

The particular strength of the Magnes collection lies in its dramatic proof of the Jewish artist's achievement in the graphic field to present divergent themes in a multiplicity of techniques. The importance of this collection rests also in the broad coverage of a period, not in the performance of one artist only. By visual comparison several commonalities are detected: the excellent workmanship based on a long crafts tradition, a decided preference for illustration, and a fascination with letters. Lastly, there is a strong inclination towards mysticism, sometimes inexplicable as in the evocative landscapes of Anna Ticho or an image by Abel Pann. The similarities found are not only based on cultural background or cross-currents but also are, not unexpectedly, of the spirit.

Catalog entries are arranged chronologically according to the birthdates of the artists.

The dimensions of the prints and drawings are in centimeters, followed by inches in parentheses, and indicate the size of plate or image, unless otherwise indicated. Height precedes width.

All biblical quotations are from *Pentateuch and Haftorahs,* edited by Dr. J. H. Hertz, C. H. (London: Soncino Press, 1960).

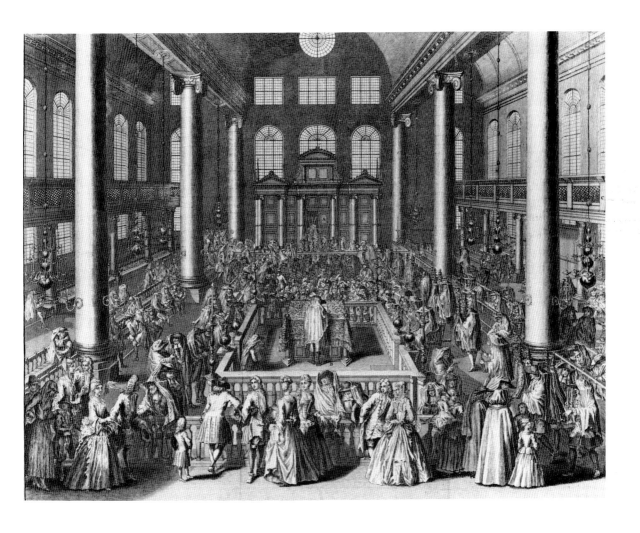

B E R N A R D   P I C A R T   b. France (1673-1733)

*La Dedicace de la Sinagogue des Juifs Portugais, à Amsterdam*

Engraving on buff laid paper
40.2 x 47 cm (15 3/4 x 18 1/2)
Gift of David Spector
77.22
Rubens 1266

The Portuguese synagogue was built in 1675 by the Sephardim of Amsterdam. It was considered the most famous synagogue in Europe by Jew and Gentile alike. A Protestant and the only non-Jew represented in this catalog, Picart in 1723 illustrated the section on Jews in an eleven-volume work on the ceremonies and religious customs of all the peoples of the world. Picart's careful and minute observations resulted in a valuable documentation of eighteenth-century Jewish life.

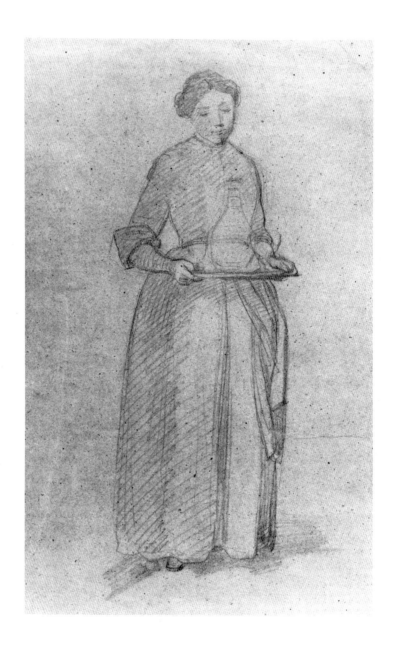

MORITZ DANIEL OPPENHEIM
b. Germany (1799-1882)

*Servant with Tray,* ca. 1850

Pencil drawing on pumice wove paper
41 x 25.5 cm (16 1/4 x 10)
Gift of the Women's Guild, Judah Magnes Museum
75.156

This drawing is a study for Oppenheim's oil painting, *Mendelssohn, Lavater and Lessing.* Commissioned and patronized by the Rothschild family, Oppenheim produced works that portray nineteenth-century German Jewish life and personalities in an idealized, romantic style.

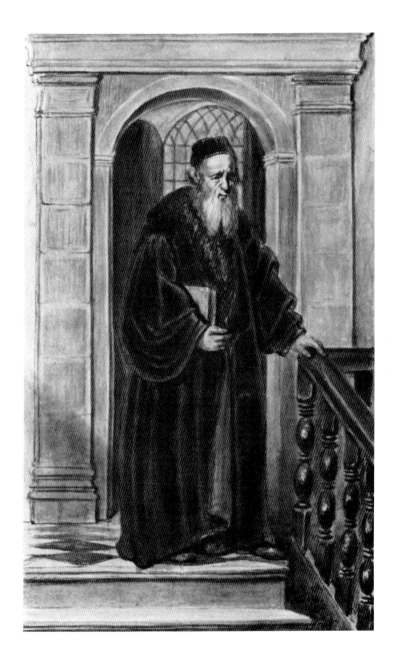

JOZEF ISRAELS    b. The Netherlands (1828-1911)

*Rabbi,* 1890

Watercolor on ivory wove paper
22.1 x 13 cm (8 3/4 x 5 1/8)
Gift of Seymour Fromer
75.16

The rich, painterly qualities of Israels' art are evidenced in the *Rabbi.* His work depicting Jewish subject matter remains an important record of nineteenth-century Jewish life in Holland.

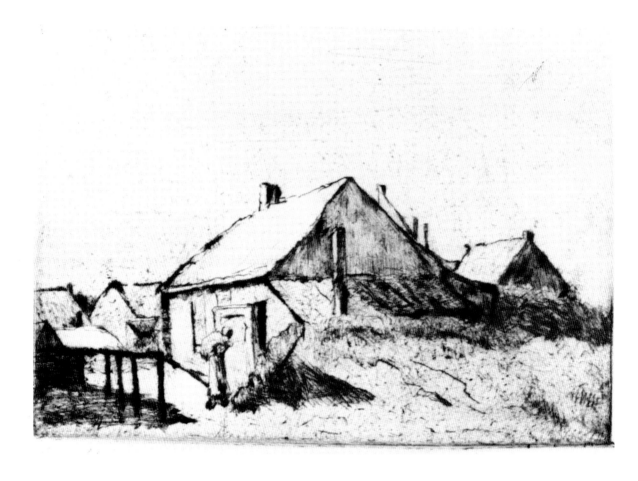

L E S S E R   U R Y   b. Prussia (1861-1931)

*Dutch Farmhouse,* 1919

Etching on buff wove paper; 63/100
14 x 20 cm (5 1/2 x 8 4/5)
Anonymous gift
75.36
Galerie Pels-Leusden 54

Ury, along with Max Liebermann and Lovis Corinth, are considered the three major German impressionists. Genre and landscape are the most prevalent themes in Ury's art.

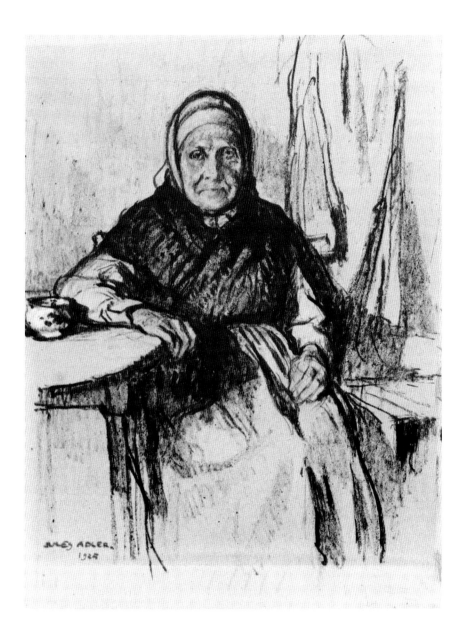

JULES ADLER   b. France (1865-1952)

*Portrait of an Old Peasant,* 1935

Ink, charcoal and pastel on gray wove paper
39.5 x 31 cm (15 1/2 x 12)
Gift of Florence and Leo Helzel in memory of Benjamin Borsuk
83.43

Adler was a prolific painter of landscapes, but he also painted the life of workers and the underprivileged, demonstrating his concern for social problems. This drawing, understated and controlled, reveals Adler's respect for the humble.

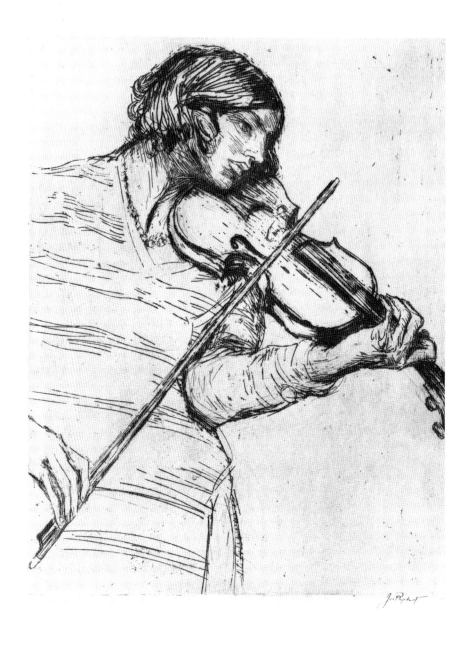

JOSEPH RAPHAEL b. United States (1869-1950)

*Girl with Violin,* ca. 1920

Etching on buff wove paper
41 x 32 cm (16 1/4 x 12 1/2)
Gift of Mr. and Mrs. Lloyd Dinkelspiel
75.97
*The Creative Frontier* 27

Known primarily for his landscape paintings, Raphael was also a graphic artist, producing 220 woodcuts and 140 etchings. This etching illustrates the artist's skill in capturing the emotional essence of his subject by using an economy of line and modeling.

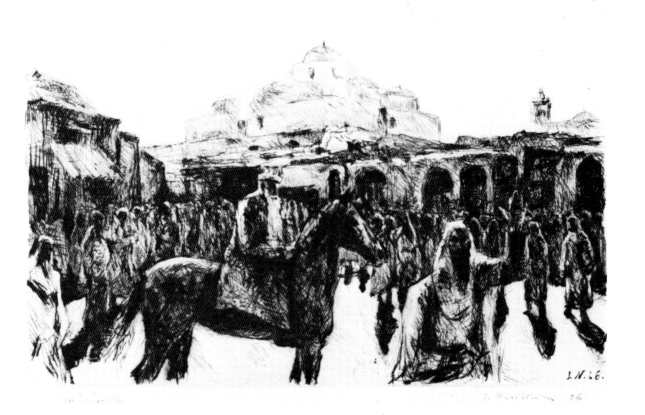

J A K O B  N U S S B A U M    b. Germany (1873-1936)

*Mordecai,* 1926

Drypoint on buff wove paper; A/P
24 x 31.5 cm (9 1/5 x 12 2/5)
Gift of Mr. and Mrs. Herbert Ballhorn and Hilda Ballhorn
82.29.2
*Memorial Exhibition, Jakob Nussbaum* 145

Nussbaum's memories of his visit to Tunis in 1903 are reflected in the unusual setting for this etching, which illustrates the biblical scene:

*Then took Haman the apparel and the horse, and arrayed Mordecai, and brought him on horseback through the streets of the city, and proclaimed before him, thus shall it be done unto the man whom the king delighteth to honor.* (Esther 6:11)

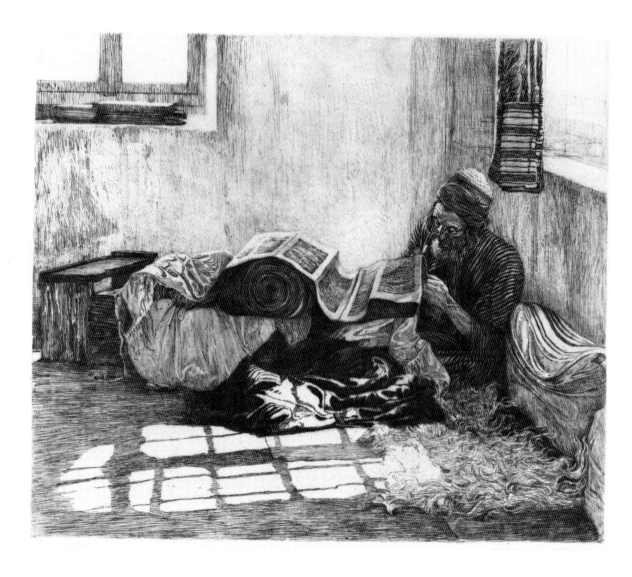

E P H R A I M   M O S H E   L I L I E N   b. Austria (1874-1925)

*Torah Scribe*

Etching on buff wove paper
43 x 49.5 cm (17 x 19 1/4)
Gift of David Spector
75.129
Brieger, p. 11
*The Hebrew Book,* p. 15

Lilien brought the Jugendstil style to Palestine in the early 1900s and employed it in many
genre scenes. In this lithograph the Scribe is sewing sections of the Torah together with a
bone needle as prescribed by Jewish law.

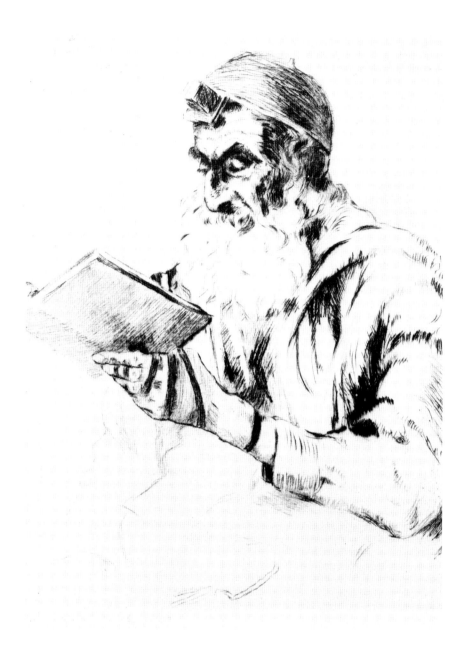

H E R M A N N   S T R U C K   b. Germany (1876-1944)

*Morgengebet* (Morning Prayers), 1928

Etching on ivory laid paper; 9/50
19.4 x 13.9 (7 3/4 x 5 1/2)
Gift of David Spector
75.48

Struck's fame rests with his etchings depicting Jewish life with warmth and compassion. He presents the orthodox Jew in prayer wearing the tefillin (boxes containing the scriptural passages) on the left hand and on the forehead.

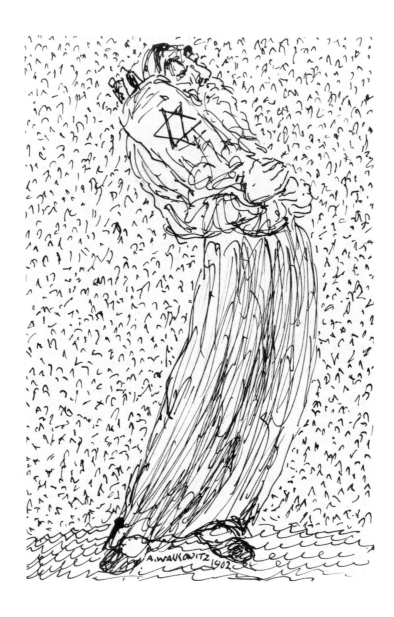

A B R A H A M   W A L K O W I T Z    b. Russia (1878-1965)

*Torah,* 1902

Pen and ink drawing on ivory wove paper
23.4 x 15.6 cm (9 1/4 x 6 1/8)
Gift of Women's Guild, Judah Magnes Museum
82.32
Lichtenstein

Much of Walkowitz's art portrayed life in the New York ghetto, which remained his
favorite subject. He was deeply influenced by his father who was a devout student of Torah,
the heart of the Jewish religion. Walkowitz was well represented with drawings and
paintings in the famed New York Armory Show of 1913.

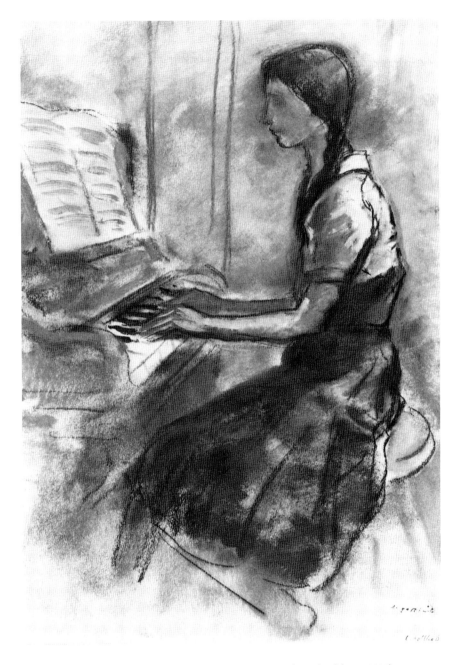

LEOPOLD GOTTLIEB   b. Poland (1883-1934)

*Young Girl at the Piano*

Oil and crayon on buff wove paper
50.5 x 35.5 cm (19 4/5 x 14)
Gift of Dr. Helene Rank Veltfort, from the estate of Doctors Otto and Beata Rank
82.16.3

Gottlieb gained fame in Poland and France as a portraitist. Influenced by impressionism, he took an active part in the experimental art movements in Paris during the early twentieth century. This work is an example of his sensitive and concise draftsmanship.

L O U I S   M A R C O U S S I S   b. Poland (1883-1941)

*Place de la Concorde,* 1930

Etching on cream wove paper; 64/154
17 x 13 cm (6 4/5 x 5 1/5)
Gift of Louise and John Sills
82.8
Lafranchis G. 56

Marcoussis is considered a major cubist artist. A painter and printmaker, he also illustrated books by eminent French authors. *Place de la Concorde* is one of ten etchings illustrating *Aurelia* by Gerard de Nerval.

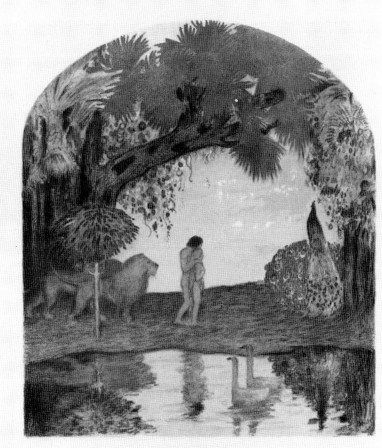

*The Garden of Eden (second version)*

A B E L   P A N N   b. Latvia (1883-1963)

*The Garden of Eden,* 1925

Color lithograph on buff wove paper; 2nd version
44.4 x 30.5 cm (17 3/5 x 12 1/5)
Gift of Dr. and Mrs. Leon Kolb
75.141

Pann's chief work was illustrations of the Bible. His aim was to present the biblical figures as simple human beings, displaying their sins and virtues, sorrows and joys. This colorful lithograph recalls:

*Therefore shall a man leave his father and his mother, and shall cleave unto his wife, and they shall be one flesh. And they were both naked, the man and his wife, and were not ashamed.* (Gen. 2:11)

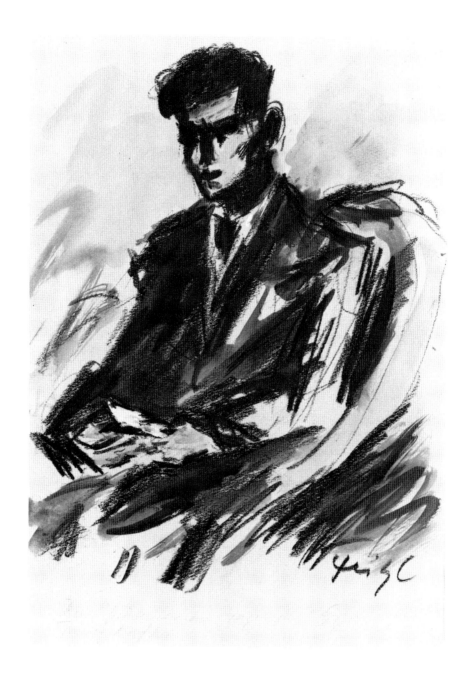

FRIEDRICH FEIGL   b. Czechoslovakia (1884-1966)

*Portrait of Franz Kafka*

Charcoal and watercolor on buff wove paper
34.5 x 24 cm (13 1/2 x 9 1/2)
Gift of Dr. and Mrs. Daniel K. Oxman
75.57
Marzynski 120

In their youth Feigl and Kafka were classmates in Prague. Feigl later became a leading artist and influence on modern Czech painting and Kafka a brilliant novelist and short story writer. The Fauve influence of the Parisian artists of the 1920s and 1930s is demonstrated in Feigl's use of arbitrary color to achieve dramatic expression.

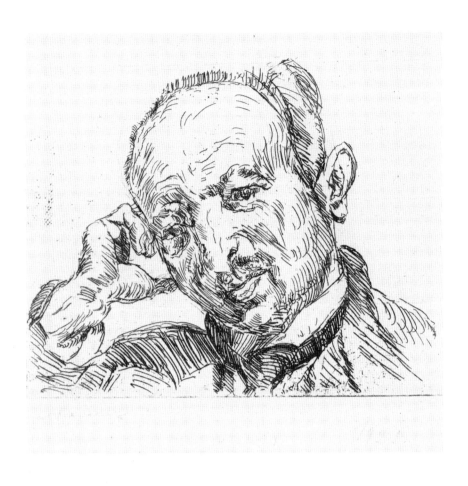

L U D W I G   M E I D N E R   b. Germany (1884-1966)

*Dr. Glaser aus Dresden,* 1921

Etching on buff laid paper; watermark: Unicorn image; A/P
14.5 x 14.5 cm (5 4/5 x 5 4/5)
Gift of Florence and Leo Helzel in memory of Joan Blair Warner
82.28

The German expressionist painter and graphic artist Ludwig Meidner created many portraits of friends and people he admired including poets, playwrights, artists, and other intellectuals of his generation. More than mere likenesses, these portraits are psychological studies of their subjects.

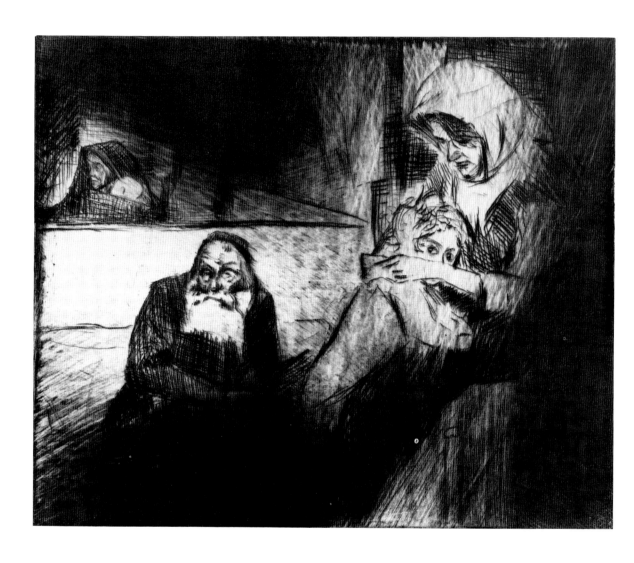

MAX POLLAK   b. Czechoslovakia (1886-1970)

*Iin Fluchtlingslager Nikolsburg-Auskammen* (In the Refugee Camp Nikolsburg—
Combing out Hair), 1914

Etching on buff wove paper; 13/75; stamp verso: Made in Austria
11.4 x 13.9 cm (4 1/2 x 5 1/2)
Gift of Dr. Elliot Zaleznik
80.15.2.4

This work is from a series of ten etchings Pollak made of the refugees at Nikolsburg,
Czechoslovakia, when he was an artist for the Austrian Army during World War I. The
refugees depicted in the camp came from Galicia. Pollak printed these etchings when he
returned to his home in Vienna.

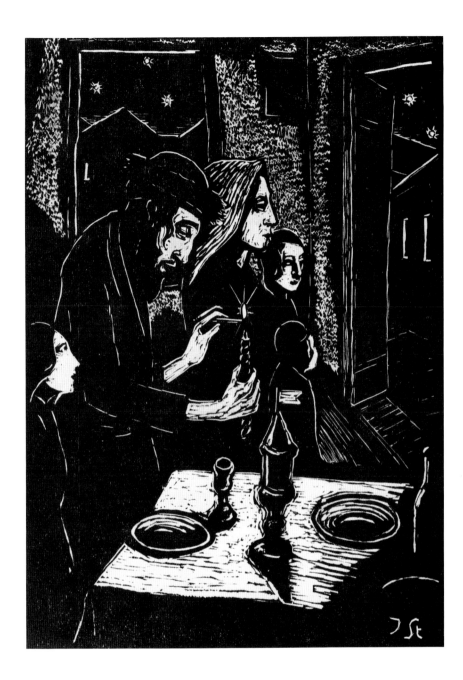

J A K O B  S T E I N H A R D T  b. Germany (1887-1968)

*Havdalah Service,* 1961

Color woodcut on ivory wove paper
36 x 24 cm (14 1/5 x 9 2/5)
Gift of Dr. and Mrs. Leon Kolb
75.303
*Encyclopaedia Judaica,* p. 1415

*Havdalah* combines Steinhardt's mastery of the woodcut technique with a favorite Judaic
theme. The artist illustrates the recitation of the blessing terminating the Sabbath, a ritual
which emphasizes the distinction between the sacred and the ordinary.

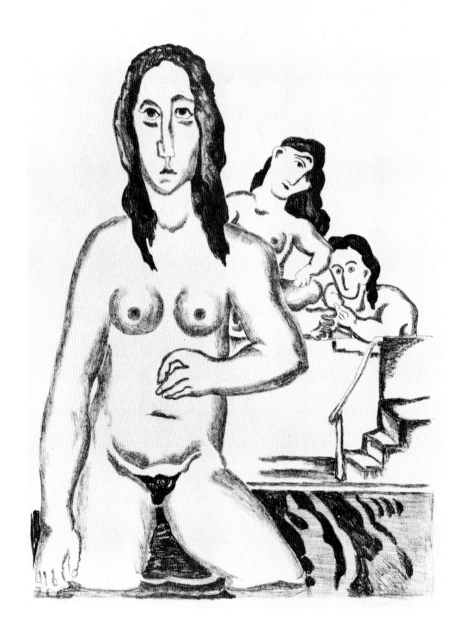

PETER KRASNOW     b. Ukraine (1887-1979)

*Ritual Bath,* 1928

Lithograph on buff wove paper
45 x 31.8 cm (17 3/4 x 12 1/2)
Gift of Leo Rabinowitz
74.26
*Peter Krasnow, A Retrospective Exhibition of Paintings, Sculpture, and Graphics* 24

Jewish subjects played a major role in Krasnow's art. This lithograph brings together an ancient tradition with the stylized modernism of the 1920s. Mikveh (ritual bath) is still used by various groups as an aid to spirituality, particularly on the eve of the Sabbath, festivals, and the Day of Atonement.

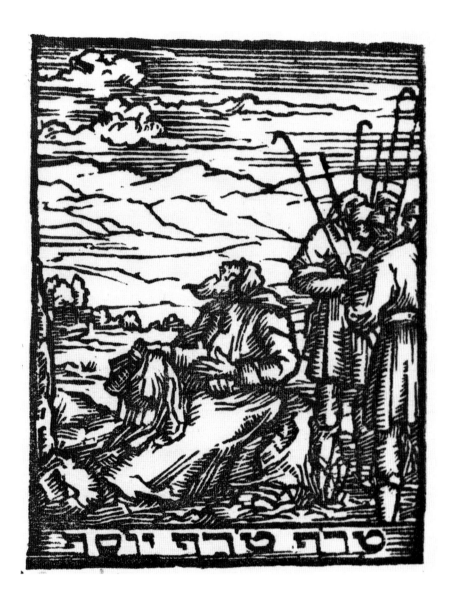

JOSEPH BUDKO   b. Poland (1888-1941)

*Jacob and his Sons*
Woodcut on ivory Japan laid paper;
from portfolio of 11 black and white woodcuts with biblical themes
6 x 4.7 cm (2 3/8 x 1 7/8)
Gift of Mr. and Mrs. Alfred Fromm
70.33.9

Budko specialized in illustrating Jewish themes — the Haggadah, Psalms, and scenes from
Genesis. His early training in metal engraving is shown in the clear, crisp lines of this
woodcut, which describes the following biblical passage:

*. . . and they took Joseph's coat, and killed a he-goat, and dipped the coat in the blood; and they sent the
coat of many colors, and they brought it to their father; and said: "This have we found. Know now whether
it is thy son's coat or not." And he knew it, and said: "It is my son's coat; an evil beast hath devoured him;
Joseph is without doubt torn in pieces."* (Gen. 37:31-33)

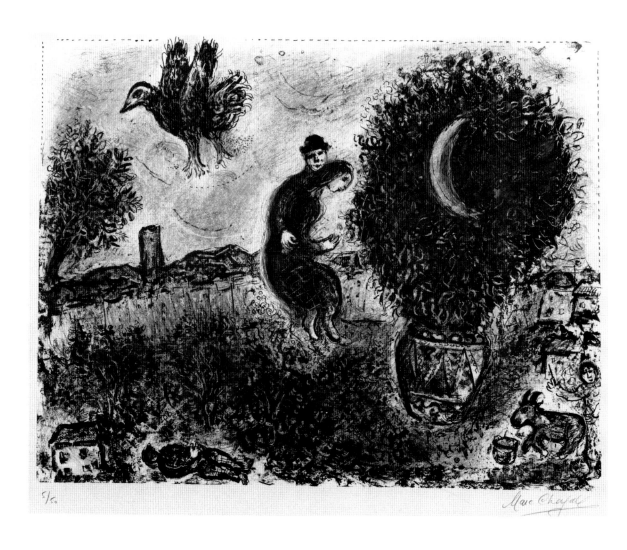

MARC CHAGALL   b. Russia 1887

*La Lune dans le Bouquet,* 1971

Color lithograph on ivory wove paper; watermark: ARCHES; 5/50, third state
59.5 x 75 cm (23 1/2 x 29 1/2)
Gift of David Caruthers; 82.63
Mourlot 626

Chagall made three versions of this romantic and joyful lithograph. The first state is in black
and white and has a person in the bouquet; the second state is in color. In this third and final
state, which Chagall worked on for several months, further changes in color were made,
and the figure in the bouquet was deleted. A prolific printmaker, Chagall remarked:

*While holding a lithograph stone or a copper plate, I thought I was touching a talisman. It seemed to me I
could place in them all my sadness, all my joys . . . everything that in the course of the years has crossed
my life: births, deaths, marriages, flowers, animals, birds . . . lovers in the night . . . .* [Charles
Sorlier, *Chagall by Chagall* (New York: Harry N. Abrams, 1979)]

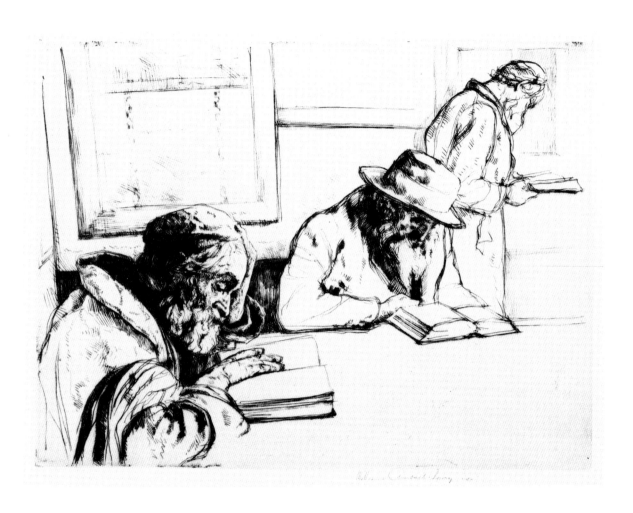

WILLIAM   AUERBACH – LEVY   b. Poland (1889-1964)

*Untitled,* 1956

Etching on cream wove paper. Proof before the removal of background and the
standing figure and before monogram was etched in a later state.
26 x 32.5 cm ( 10 1/4 x 13 1/8)
Gift of Julius Kahn III in memory of Julius Kahn II
79.80.3

This etching is characteristic of Auerbach-Levy's warm and dignified portrayals of Jewish
life in New York's East Side. He specialized in depicting the scholar and Torah.

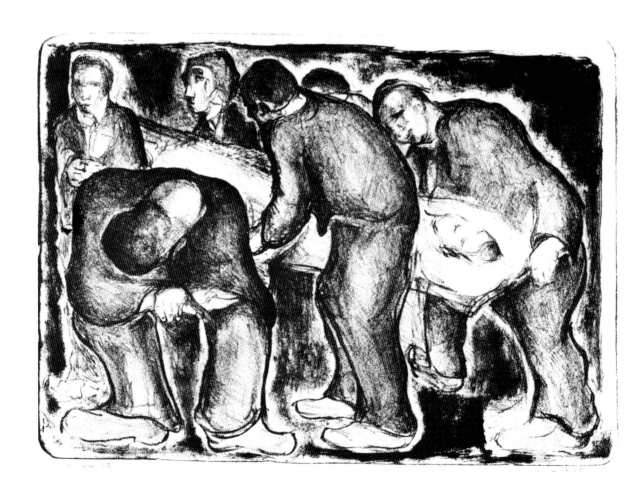

ISIDORE   ASCHHEIM   b. Germany (1891-1968)

*Verunglückte* (The Victim), 1950

Lithograph on ivory wove paper; 10/20
26 x 37.5 cm (10 1/2 x 15)
Gift of Mrs. Joseph Aschheim
80.3.3

Aschheim settled in Jerusalem in 1940, at a time when German expressionism was deemed decadent and thus outlawed by the Nazis. His style mellowed by contact with his adopted country; however, *The Victim* embodies the expressionist's tendency to distort form for emotional emphasis.

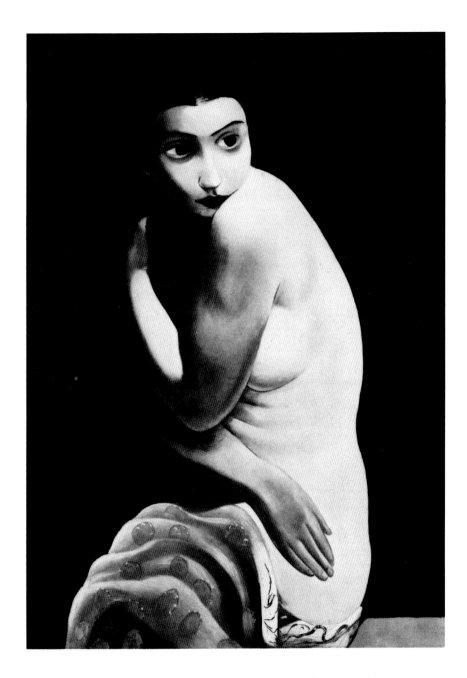

M O I S E   K I S L I N G   b. Poland (1891-1952)

*Seated Woman,* 1926

Color etching and aquatint on buff wove paper; 38/100
65 x 44.7 cm (26 3/4 x 18)
Gift of Anton Marguleas
75.63
Pelz 14

Portraits and nudes were favorite themes for Kisling. He was a friend of Modigliani and an important member of the Jewish School of Paris during the 1920s and 1930s.

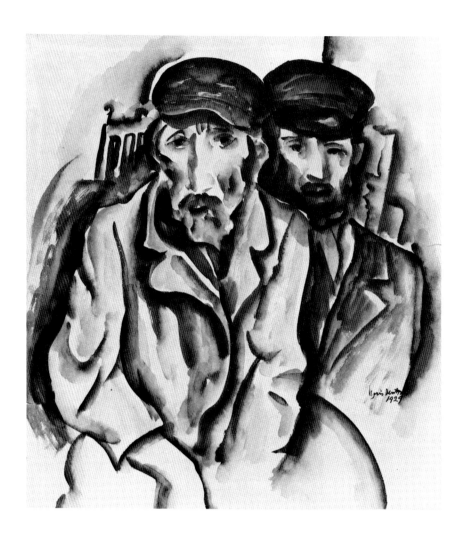

BORIS DEUTSCH    b. Russia (1892-1978)

*Village Tradesmen,* 1929

Watercolor on buff wove paper
34 x 30.5 cm (13 1/2 x 12 1/2)
Bequest of the artist's estate
81.64

Deutsch portrayed characters from the Russian shtetl he left when he immigrated to the United States in 1916. Elongating and distorting his figures, he achieved a personal interpretation of his subject.

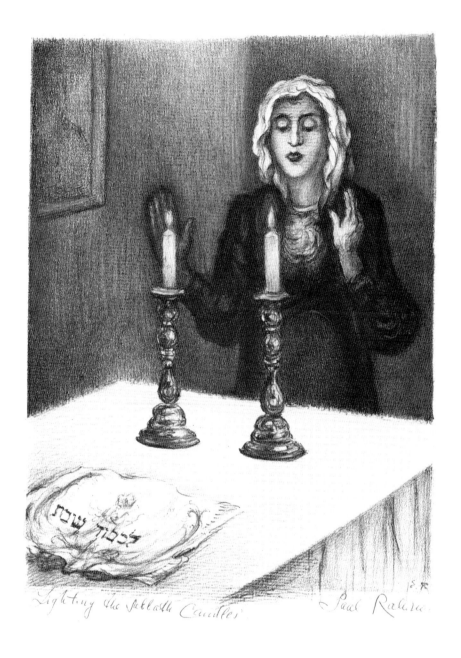

Lighting the Sabbath Candles

**S A U L   R A B I N O**   b. Russia 1892

*Lighting the Sabbath Candles*

Color lithograph on cream laid paper
50.5 x 31.5 cm, sheet (20 x 12 1/4, sheet)
Gift of Sanford Koretsky
76.221

Rabino's art is deeply rooted in Judaism. A typical example of his work portraying rituals and ceremonies, this lithograph illustrates the Sabbath prayer:

*Blessed are You, Lord our God, King of the Universe, who has made us holy by His commandments, and commanded us to kindle the Sabbath lights.* (traditional prayer book)

A B R A H A M   R A T T N E R   b. United States (1893-1978)

*Near the Sea of Galilee,* 1966

Color lithograph on ivory wove paper; A/P
56.7 x 75.5 cm (22 1/4 x 30)
Gift of Esther Gentle
78.55

Rattner is renowned for his work in stained glass describing biblical or religious themes.
This highly abstract and colorful landscape suggests the influence of Byzantine mosaics and
Greek icons on the artist's style.

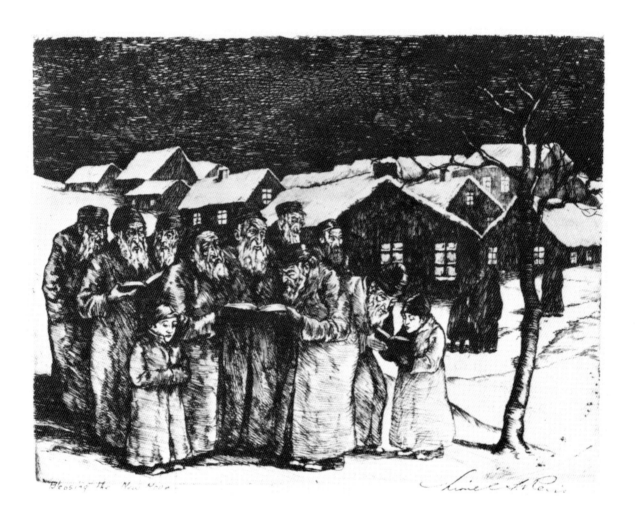

L I O N E L   S.   R E I S S    b. Austria 1894

*Blessing the New Moon*

Etching on cream wove paper
17 x 21.2 cm (6 3/4 x 8 1/2)
Anonymous gift
62.184
*My Models Were Jews*, p. 98
*New Lights, Old Shadows*, p. 119

Reiss concentrated on Jewish subjects in his paintings and graphic art. His art documents Jewish life in the United States, Europe, North Africa and the Near East. This etching portrays the reciting of a prayer of thanksgiving to welcome the *shekhinah* (Divine Presence) during the reappearance of the new moon.

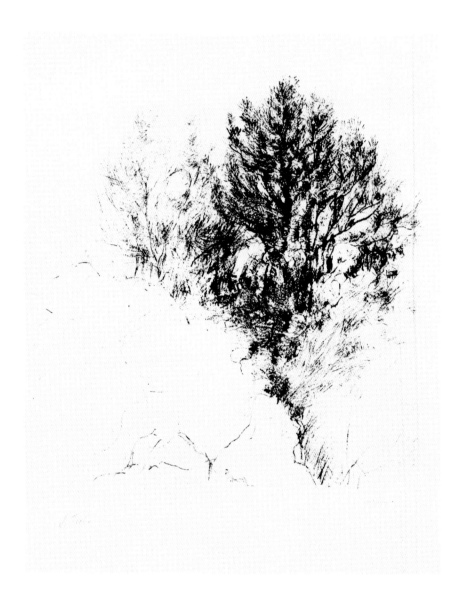

A N N A    T I C H O    b. Austria (1894-1980)

*Olive Trees,* 1979

Lithograph on ivory wove paper; watermark: CREYSSE FRANCE; 113/150
73.4 x 53.5 cm (29 x 21 1/4)
Gift of Florence and Leo Helzel in memory of Annie Borsuk
83.2

Ticho's passion for Jerusalem's landscape was expressed in many prints and pastels. For more than fifty years, she drew the hills, mountains, stones and trees of her adopted country in a manner that reflected her meticulous, observant eye. This portrait of an olive tree, whose evergreen leaf is a biblical symbol for peace, is typical of Ticho's later impressionistic style.

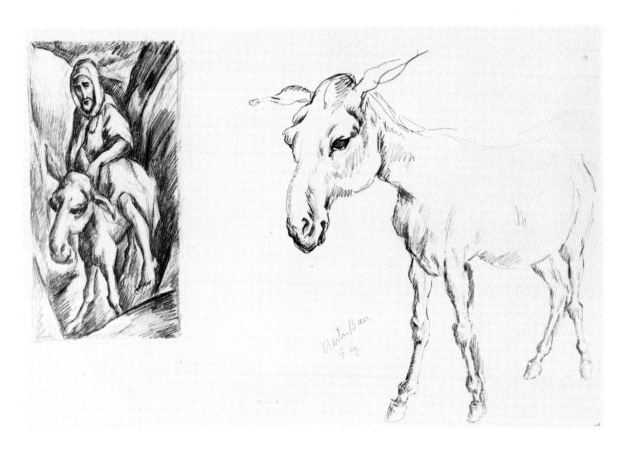

MARTIN  BAER    b. United States (1894-1961)

*Studies,* 1927

Pencil drawing on buff wove paper
26 x 41 cm (10 1/4 x 16 1/4)
Gift of Nata Piaskowski
82.15.2

Bedouins were a familiar subject for Baer, who lived in Algeria for several years in the 1920s. A fine draftsman, Baer turned his sketches into brilliantly colored, exotic paintings.

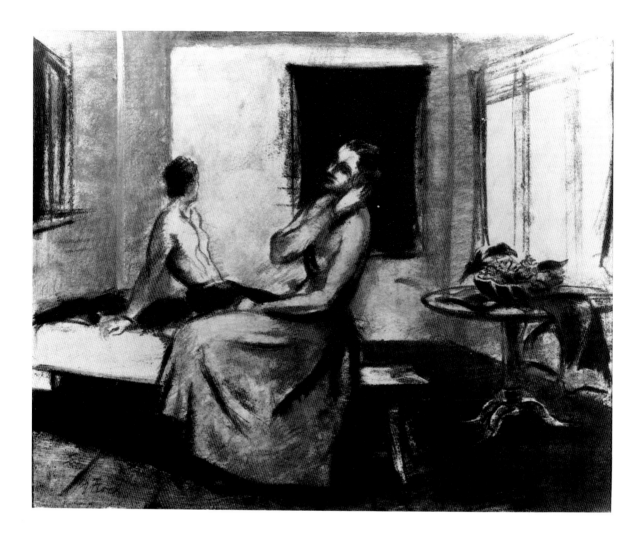

JOSEPH FLOCH  b. Austria (1895-1977)

*Two Women*

Oil and crayon on buff cardboard
29 x 36 cm (11 1/2 x 14 1/4)
Gift of Dr. Helene Rank Veltfort, from the estate of Doctors Otto and Beata Rank
82.16.1

Rejecting contemporary art trends such as cubism and surrealism, Floch was a leader in the neo-romantic movement. *Two Women* encompasses a mood of quiet contemplation that typically pervades Floch's art.

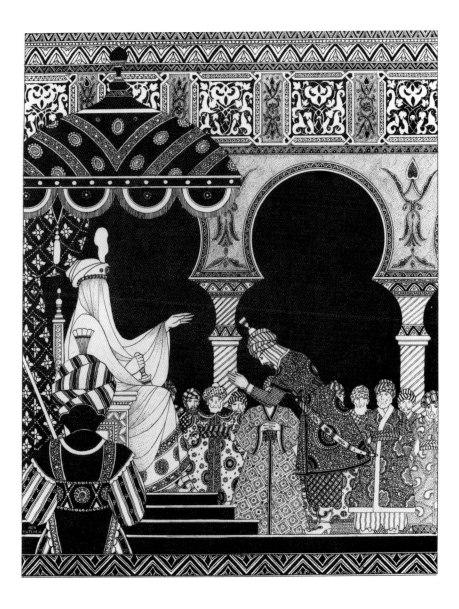

B E N  K U T C H E R  b. Russia (1895-1967)

*For Thee, Young Warrior, Welcome,* ca. 1920

Pen and India ink on dark buff wove paper
36.2 x 28.3 cm (14 3/8 x 11 1/4)
Gift of Mrs. Ben Kutcher
77.228.2

This drawing, rich in architectural detail and design, is one of a series illustrating the book, *Lalla Rookh,* by the famed Irish poet and author Thomas Moore. Kutcher reached his artistic peak in these black and white drawings reminiscent of the work of Aubrey Beardsley, the nineteenth-century English artist.

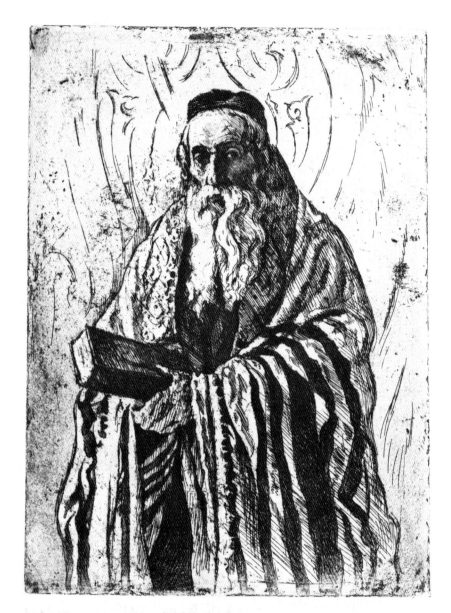

J O S E P H   M A R G U L I E S    b. Austria 1896

*Universal Rabbi*

Etching and aquatint on white wove paper; 206/250
25.2 x 18.5 cm (10 x 7 3/10)
Gift of David Spector
75.69

Margulies is renowned for his paintings of American political figures. He is also a graphic artist whose work displays warmth and feeling for his heritage.

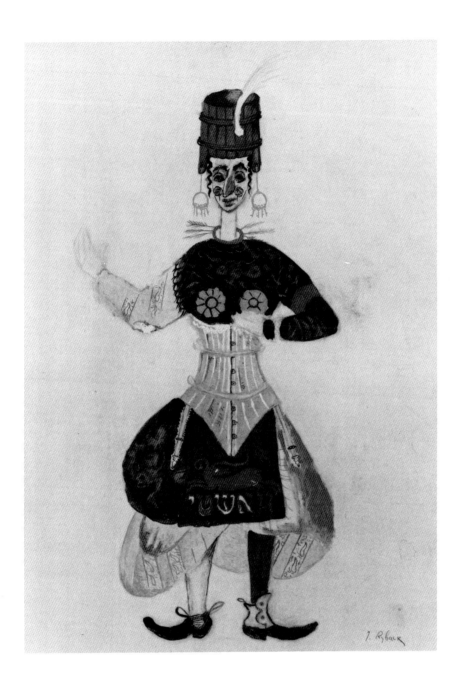

ISSACHAR RYBACK    b. Russia (1897-1935)

*Vashti,* ca. 1924

Gouache and conté on ivory wove paper
65 x 44.5 cm (23 3/4 x 17 1/2)
Gift of Dr. Elliot Zaleznik
83.48.2

Ryback, an early twentieth-century avant-garde Russian artist who developed a cubist style, depicted many scenes of Jewish life in the shtetl and in the Ukrainian fields. He also designed sets and costumes for the Ukrainian Jewish State Theatre. Vashti, one of Ahasuerus' wives in the Book of Esther, wears the costume Ryback designed for a Purim play. The work is an example of the artist's innate humor and sense of color.

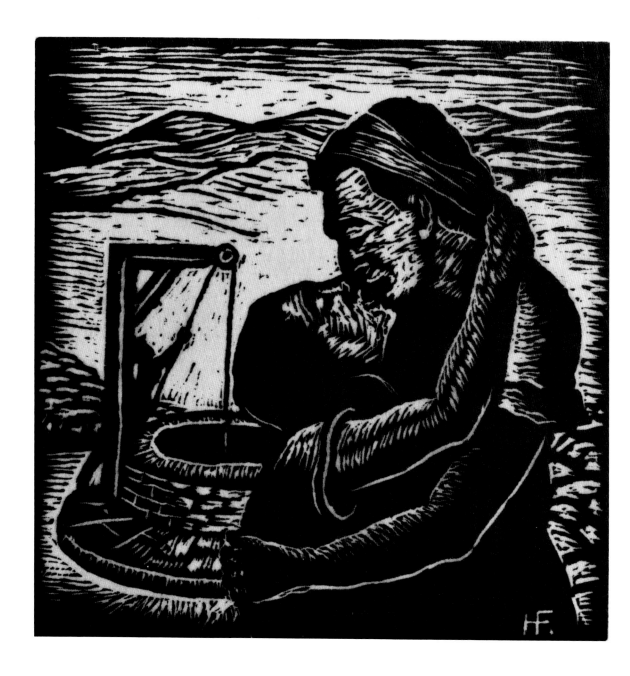

HERMANN FECHENBACH   b. Germany 1897

*Jacob Labors to Win Rachel,* ca. 1925

Woodcut on ivory wove paper; No. 28 from 135 woodcuts depicting scenes of Genesis
6.5 x 6.5 cm (2 1/2 x 2 1/2)
Gift of the artist
77.34
Fechenbach, p. 132

Fechenbach, primarily a painter, was also a gifted woodcut artist. His skill in interpreting human emotions is demonstrated in this tender biblical scene:

*Jacob kissed Rachel and lifted up his voice and wept.* (Gen. 29:11)

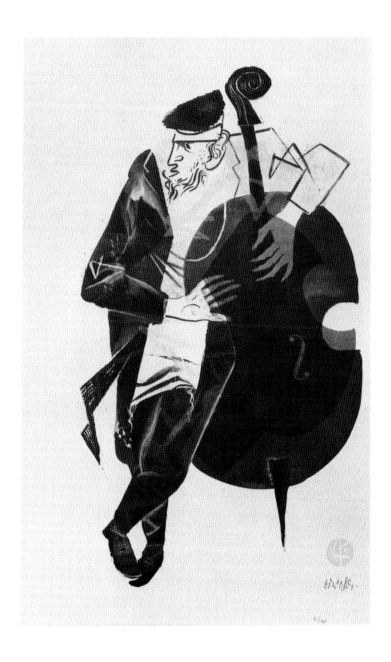

W I L L I A M   G R O P P E R   b. United States (1897-1977)

*Untitled,* 1967

Color lithograph on ivory wove paper; chops: Tamarind's bell-shaped form; four-leaf
clover, Don Kelley, printer; 11/20
56.5 x 38 cm (22 1/5 x 15)
Gift of Florence and Leo Helzel in memory of Simon Barth
83.47

This caricature of a Jewish musician is one of ten individual works Gropper produced at the
Tamarind Lithography Workshop in 1967. During his fellowship there, the artist also
completed three suites, *The Shtetl, Unfinished Symphony,* and *Sunset Strip.*

BEN SHAHN b. Lithuania (1898-1969)

*Frontispiece, Haggadah for Passover,* 1966

Lithograph with hand coloring and applied gold leaf on ivory laid paper;
Watermark: ARCHES
39 x 59.7 cm (15 1/4 x 23 1/2)
Museum purchase through donation of Jay Espovich in memory of Norman Espovich
83.49

This lithograph is the frontispiece for Shahn's illustrated *Haggadah for Passover,* number 214 from 228 copies. Printed at the famed Mourlot workshop in Paris, the frontispiece combines Shahn's distinctive calligraphy with a Judaic theme. Written under the menorah is the well-known prayer of celebration recited during Jewish holidays and at special family gatherings: "Blessed art thou, Lord our God, King of the universe, who hast granted us life and sustenance and permitted us to reach this occasion."

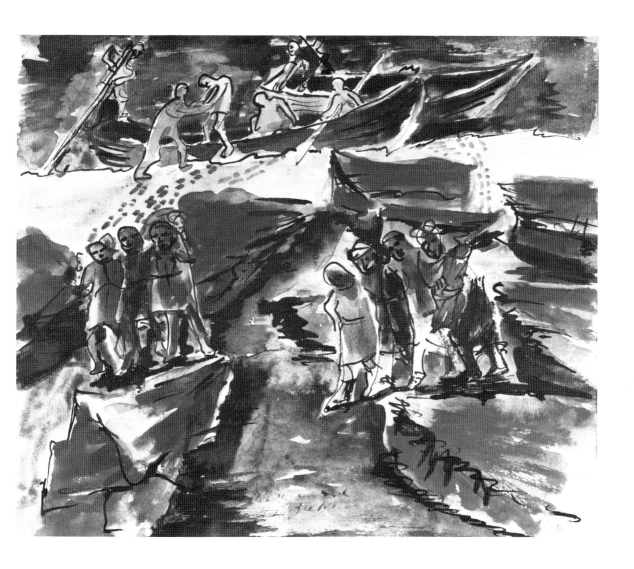

BERNARD BARUCH ZAKHEIM  b. Poland 1898

*Landing without Certificates or Aliyah "Beth"*

Watercolor on cream wove paper
20.3 x 24 cm (8 x 9 1/2)
Gift of Seymour Fromer
76.61

Zakheim is well known in California for large-scale murals on social themes. In this watercolor he depicts the illegal immigration of concentration camp survivors into Palestine.

R A P H A E L   S O Y E R   b. Russia 1899

*Portrait of Isaac Bashevis Singer,* ca. 1969

Color lithograph on ivory wove paper; chop: BSA; watermark: ARCHES; 133/150
65 x 48 cm (25 1/2 x 19)
Gift of Jacques and Esther Reutlinger
82.51

Soyer and the Nobel Prize author Singer have been friends for over thirty-five years. Soyer illustrated several of Singer's fictional works and his autobiographical story, "A Young Man in Search of Love." Portraits and figure studies are Soyer's strongest and most important works. They are straightforward and simple in compositional design and do not flatter his subject. He says of his work:

*I am sympathetic, but I don't think that I overdo it. I don't think that I am sentimental. I'm truthful when I delve into the personalities of the people I do.* [Frank Gettings, *Raphael Soyer, Sixty-five Years of Printmaking* (Washington, D.C.: Smithsonian Institution Press, 1982), p. 8]

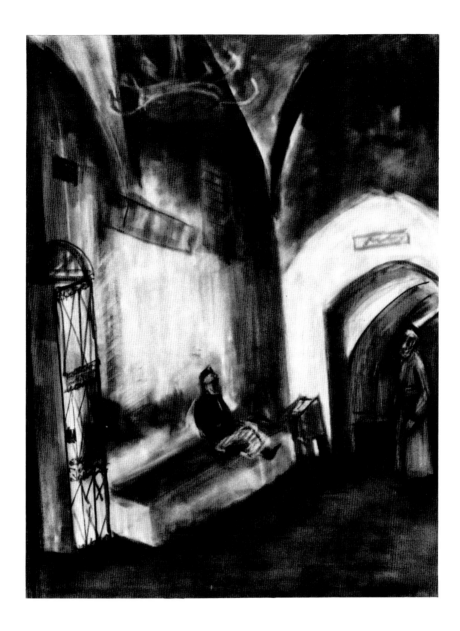

MAX BAND    b. Lithuania (1900-1974)

*Untitled*

Pastel on buff wove paper
48.5 x 37 cm (19 x 14 1/2)
Gift of Mrs. Janet M. Weinstein
78.18.1

Band painted only what he loved, especially Jewish subjects represented in reflective, often lonely moods. This pastel depicts a reading room of a Moorish style building, probably a synagogue in North Africa.

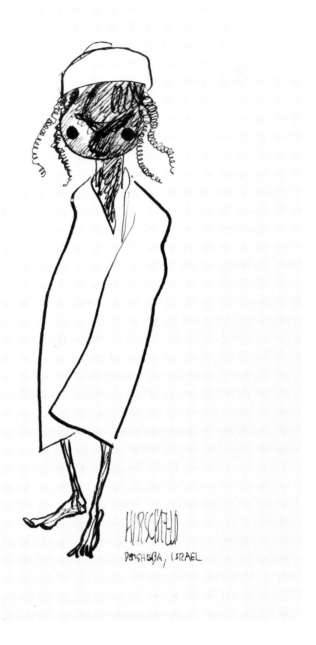

A L  H I R S C H F E L D    b. United States 1903

*Yemenite Boy,* 1953

Pen and ink drawing on ivory cardboard
38 x 22.4 cm (15 x 8 3/4)
Gift of the artist
75. 38
The Margo Feiden Galleries 365

*Yemenite Boy* embodies Hirschfeld's distinctive, spontaneous, fine-line style. This drawing is reminiscent of thousands of playful caricatures of Broadway's theatrical personalities Hirschfeld has produced for the Sunday *New York Times* since 1925.

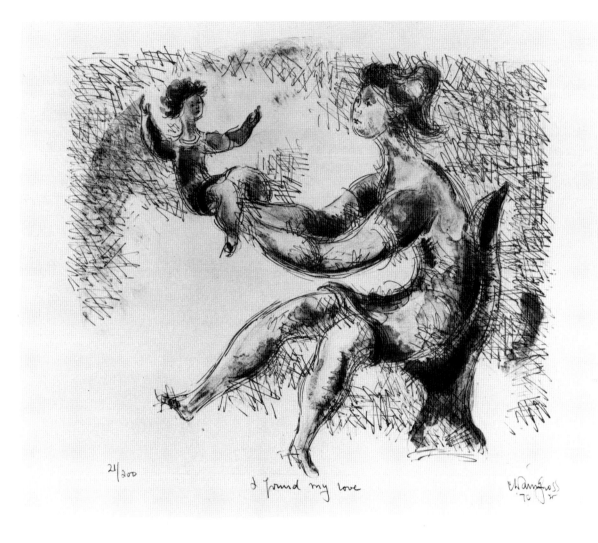

21/200         I found my love       Chaim Gross '70

C H A I M   G R O S S      b. Austria 1904

*I Found My Love,* 1970

Color lithograph on ivory wove paper; watermark: BFK RIVES; 21/200
39 x 46 cm (15 1/4 x 18 1/4)
Gift of Mr. and Mrs. Leo Krashen
77.254

The theme of mother and child appears repeatedly in Gross' sculptures, paintings, water-
colors, and prints. Distortion of the human body in action for balance and design is a device
Gross employs in his art. His style bears influences from boyhood recollections of acrobats
who performed in Gross' native shtetl.

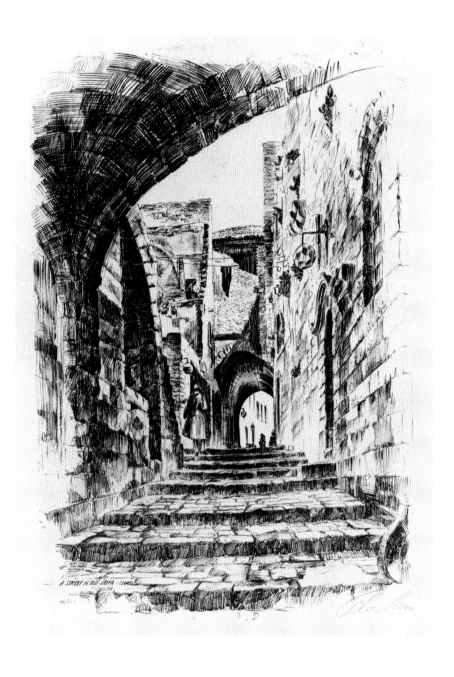

A L E C   S T E R N   b. United States 1904

*A Street in Old Jaffa,* 1965

Lithograph on ivory laid paper; 44/200
57 x 44 cm (22 1/2 x 17 1/4)
Gift of Norman Landsberg
75.329

*A Street in Old Jaffa* is one of the forty lithographs Stern produced illustrating Israel. The artist's wife climbs the stone steps in this work, which displays Stern's concern for architectural detail.

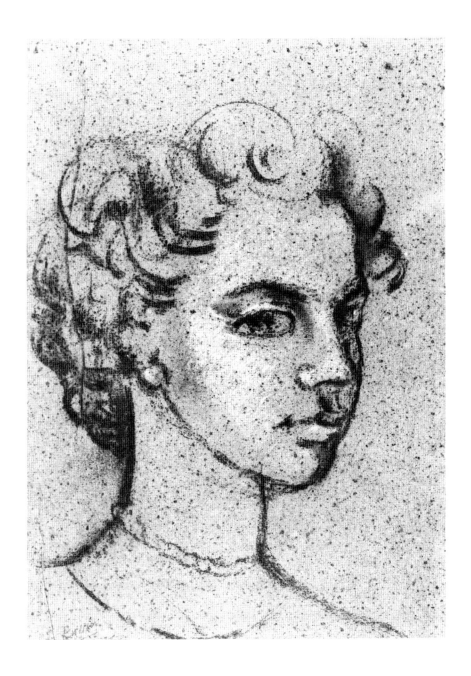

ROBERT I. RUSSIN   b. United States 1914

*The Italian Girl,* 1954

Charcoal and pastel drawing on hand-made, gray-flecked paper
45.5 x 31.2 cm (18 x 12 1/4)
Gift of Mrs. Milah R. Wermer in memory of Dr. Paul L. Wermer
83.13

The sculptor Russin is acclaimed for his public monuments of American historical figures.
Drawn while the artist was living in Florence, Italy, *The Italian Girl* is an unusual example of
Russin's work.

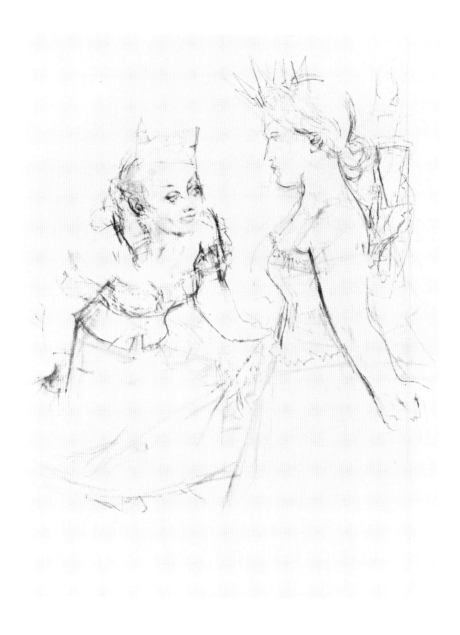

JACK  LEVINE   b. United States 1915

*Bienvenue*

Lithograph on ivory wove paper; watermark: ARCHES; 74/125
75.5 x 57.5 cm (29 4/5 x 22 7/10)
Gift of Anton Marguleas
75.277

Levine was commissioned by Atelier Mourlot to create *Bienvenue*. It depicts the U.S. Goddess of Liberty receiving her French counterpart, Marianne. Levine also produced a poster version of *Bienvenue* with red and blue added. He has created many other works of art depicting Jewish themes, especially biblical subjects.

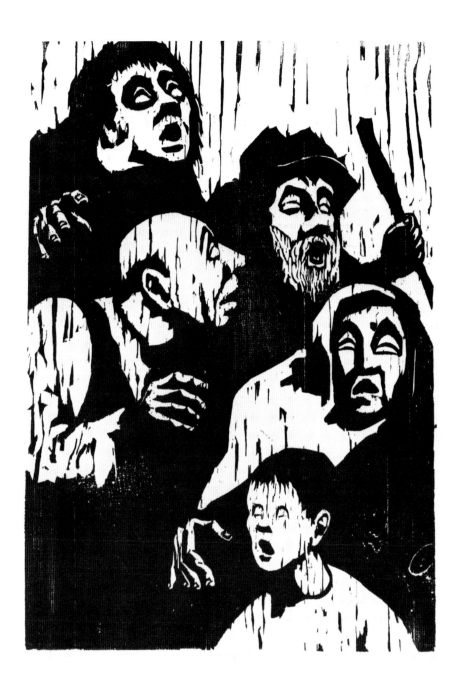

J A C O B   P I N S    b. Germany 1917

*Blind People,* 1957

Woodcut on ivory Japan paper, 4/22
74 x 55 cm, sheet (29 1/4 x 20, sheet)
Gift of the artist
83.45.1
*Jacob Pins 2*

Pin's bold and dramatic style reflects the influence of Japanese woodblock prints. The texture of the wood is an integral part of the picture. Pins has stated:

*. . . in teaching both the graphic and the free arts, the woodcut should be an instrument of great importance. It trains the student to self-control, makes him look ahead and gives a sense of finality, therefore, of responsibility.* [*Jacob Pins* (Berkeley: Magnes Museum, 1974)]

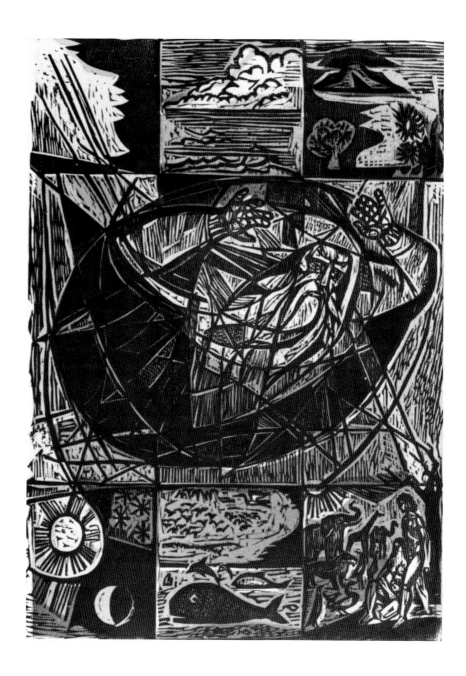

IRVING   AMEN   b. United States 1918

*Creation*, 1970

Color woodcut on ivory wove paper; watermark: RIVES; A/P
43 x 30.2 cm (17 x 12)
Gift of the artist
79.30.1

*Creation* demonstrates Amen's firm, carved woodcut line and his brilliant use of color. The subject evokes the following biblical quotation:

*. . . and God said: "Let us make man in our image, after our likeness; and let him have dominion over the fish of the sea, and over the fowl of the air, and over the cattle, and over all the earth, and over every creeping thing that creepeth upon the earth."* (Gen. 1:15)

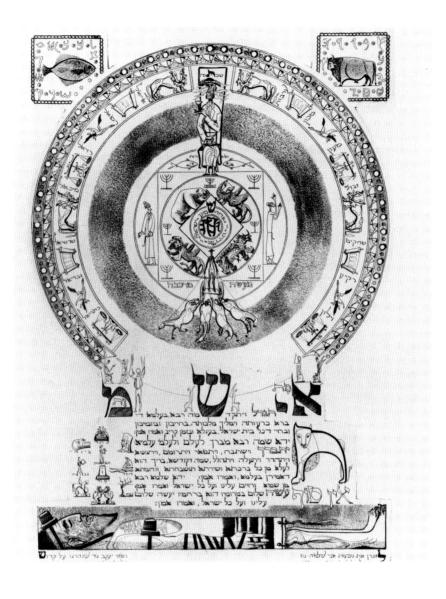

A B R A M   K R O L   b. Poland 1919

*Kaddish*

Etching and drypoint on ivory wove paper; watermark: BFK RIVES; 37/60
65.5 x 59 cm (26 x 19½)
Gift of Dr. and Mrs. Daniel K. Oxman
76.109
*Encyclopaedia Judaica* 662, Volume 10

Krol's *Kaddish* memorializes his parents and brother who were killed by the Nazis. Kaddish, the sacred prayer for the dead, transforms the mourner's personal grief into a chant that praises God and hopes for a better life for all. Krol uses a highly personal vocabulary of Hebrew and universal symbols that refer to the afterlife.

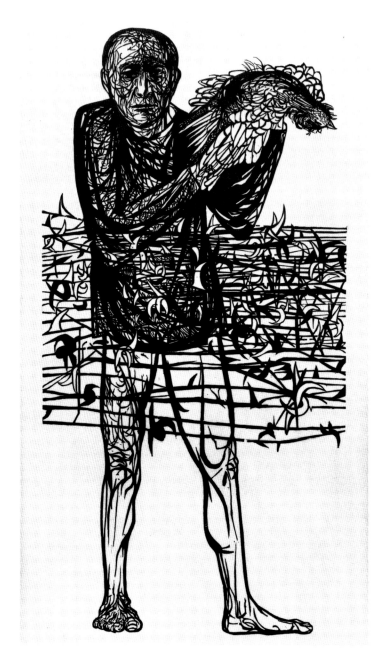

L E O N A R D   B A S K I N   b. United States 1922

*Man of Peace,* 1952

Woodcut on cream, oversized Tableau American paper; edition not numbered
168 x 91 cm (66 1/2 x 36)
Gift of Mr. and Mrs. Allan P. Sindler
75.198
Una Johnson 69

Baskin's most widely publicized graphic work, *Man of Peace,* was part of a series of twelve
large woodcuts produced from 1952 to 1970. The human figure is presented in an unusual
manner, expressing Baskin's fascination with historical anatomy books and *écorché* (flayed
anatomy). *Man of Peace* may be understood as "Kapparah," a ceremony during which Jews
offer a cock for the expiation of sins the day before the Day of Atonement. The following is
repeated three times in Hebrew: "This be my substitute, my vicarious offering for
atonement. This cock shall meet death, but I shall find a long and pleasant life of peace."

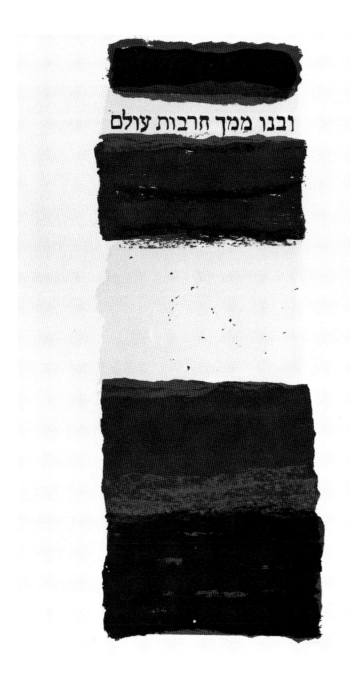

RACHEL LANDES    b. United States 1924

*Rebuilders*, 1981

Color screenprint on ivory wove paper; 1/50
70 x 52.5 cm (25 3/4 x 20 3/4)
Museum purchase from artist
81.16

Landes was commissioned by the Magnes Museum to create a print to commemorate her exhibition at the Museum in 1981. Her work pays tribute to those who took part in rebuilding Israel:

*Ye shall be rebuilt and I will raise up the destroyed places.* (Isaiah 44:26)

H A R O L D   A L T M A N   b. United States 1924

*Untitled*

Color lithograph on ivory wove paper; watermark: BFK RIVES; 33/50
56 x 75.5 cm (22 x 29 3/4)
Gift of Mr. and Mrs. Allan P. Sindler
74.34

Altman's favorite subject of people in parks is mirrored in this lithograph. The lone, dream-like figure is rendered in the artist's light, impressionistic style.

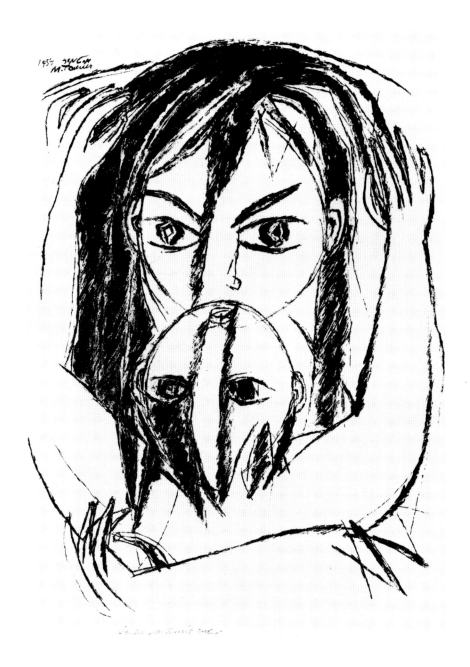

M O S H E  T A M I R   b. Russia 1924

*Mother and Child*, 1954

Lithograph on ivory wove paper; 69/200
67.2 x 47 cm (26 1/2 x 18 1/2)
Gift of Dr. and Mrs. Leon Kolb
75.281
Tammuz & Wykes-Joyce 64

*Mother and Child* reflects the expressionist and symbolist influences on Tamir's art. The composition is forceful and austere, similar to the artist's painting style.

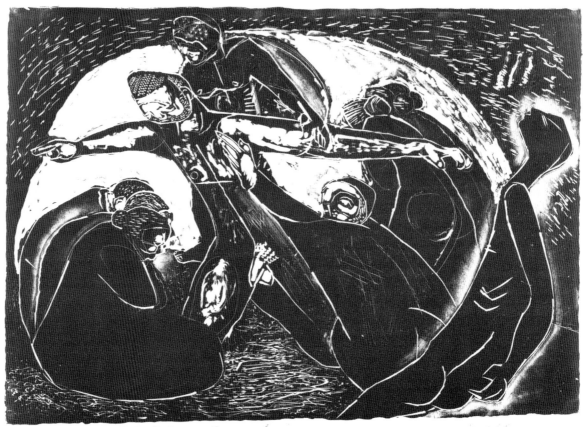

HAROLD PARIS    b. United States (1925-1979)

*The Moloch Eats Every Day,* 1973

Woodcut on buff Japan paper; No. 3 from Buchenwald series
27 x 35 cm (10 1/4 x 14)
Gift of the artist
77.4.3
Peter Selz, p. 13

Paris's *Moloch,* an ancient Semitic god, depicts destruction and evil appeased by human sacrifice. Paris employs the woodcut line to intensify the emotional impact of his subject.

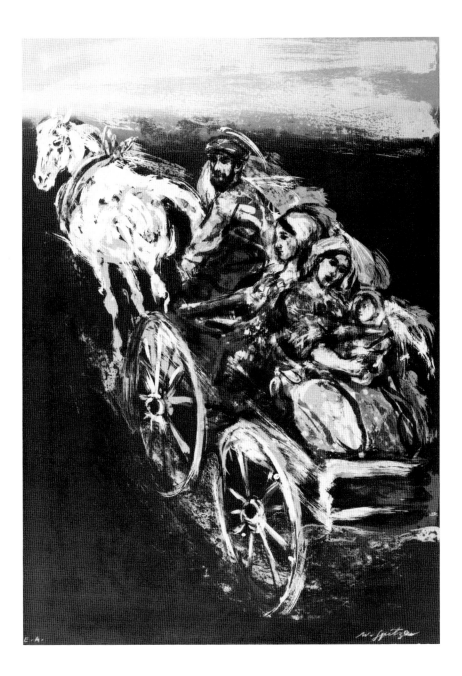

W A L T E R   S P I T Z E R    b. Poland 1927

*La Charette*

Color lithograph on ivory wove paper, E.A.; edition of 120
75 x 53.4 cm (29 1/2 x 21)
Gift of the artist
83.17.1

Spitzer, a prominent heir to the Jewish School of Paris, communicates nostalgia for his heritage. By employing brilliant colors of equal value and bold diagonals, the artist creates a heightened tension in his work.

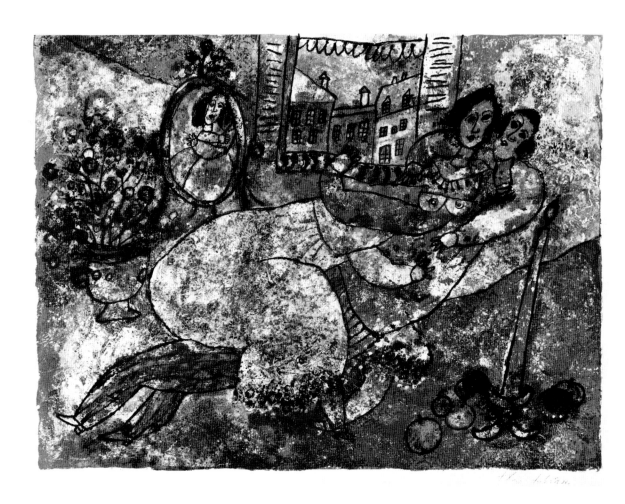

THEO  TOBIASSE   b. Israel 1927

*The Song of Songs of King Solomon,* 1976

Color lithograph on white Japan paper; H. C. LXV
(from portfolio of 12 colored lithographs)
55 x 75.7 cm (21 1/2 x 29 3/4)
Gift of Doctors Madlyn and H. Thomas Stein
82.65.11

Much of Tobiasse's art is concerned with the history of the Jews. This lithograph is from a
series that illustrates the lyric love songs of King Solomon. Tobiasse employs brilliant colors
and exaggerated forms that are compatible with the extravagant expressions and incongru-
ous comparisons contained in the songs.

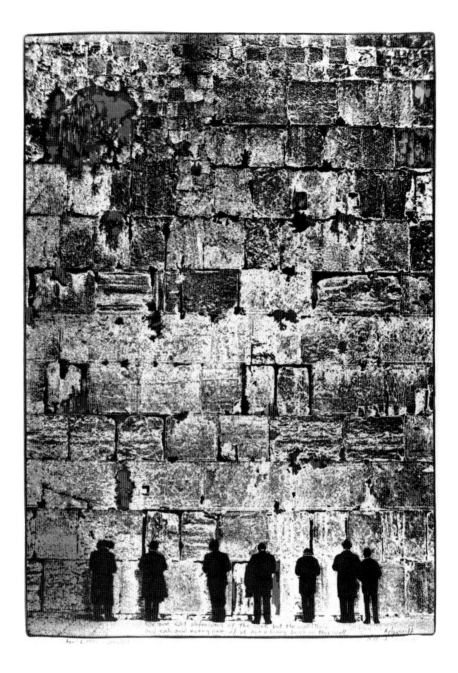

ALBERT  GARVEY   b. United States 1932

*We Are the Wall Itself,* 1974

Color screenprint on ivory wove paper;
chop: (c) Albert Garvey 1974; watermark: France; 1/100 from portfolio of 24 screenprints
(*A Portrait of Israel*)
72.5 x 50 cm (28 1/2 x 19 3/4)
Gift of the artist
75.10

*We are not the defenders of the Wall, but the Wall itself and each and every one of us are a living brick of this wall.*—Chaim Arlosoroff

Commissioned by the Magnes Museum to produce a portfolio of prints on Israel, Garvey based his work on photographs he and his wife took while visiting the country for three months. Garvey's prints contain quotations from Jewish literature and strong colors emphasizing the vitality he found in Israel.

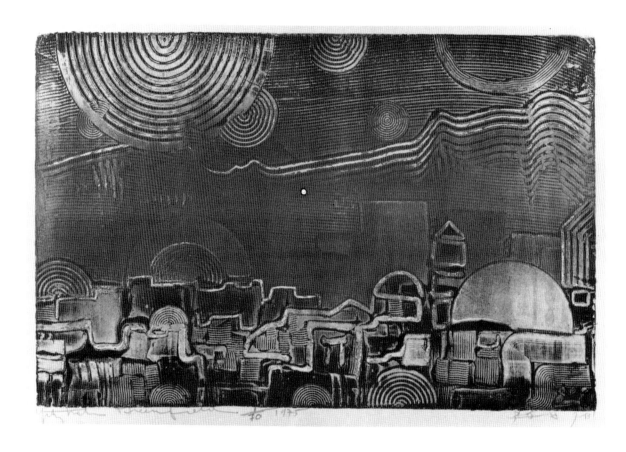

YITZHAK GREENFIELD    b. United States 1932

*Jerusalem,* 1975

Color etching and aquatint on ivory wove paper; 1/70
26.5 x 40.2 cm (10 3/8 x 16)
Museum purchase from artist
76.233

Commissioned by the Magnes Museum, *Jerusalem* reflects Greenfield's feeling for the
ancient city:

*Jerusalem has always been in my mind's eye . . . it has encompassed my inner world, become my inner
landscape . . . it is a world of light and mystery. Stones, buildings and books quiver with history. My
interest in the Bible, Cabala and archaeology became a daily revelation.*

The calligraphic line and reference to the *Sephirot* (spheres of energy) are related to the
Cabala, a strong influence on Greenfield's work.

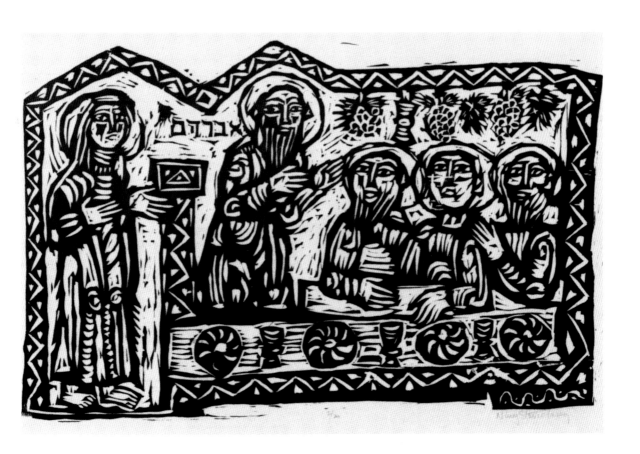

NIKOS STAVROULAKIS   b. Greece 1932

*Abraham and the Visitors,* 1968

Woodcut on ivory laid paper; 2/20
42.2 x 62 cm (16 1/2 x 24 4/5)
Gift of the artist
77.42
*Woodcuts by Stavroulakis* 29

Stavroulakis draws on many sources to create his woodcut style — German expressionism, Japanese woodblock prints, African sculpture, and medieval woodcuts. This woodcut illustrates the following passages:

*One to announce the tidings of the birth of Isaac; the second to destroy Sodom; and the third to rescue Lot.* (Gen. 18:2)

*An angel is never sent on more than one errand at a time.* (Midrash)

L E E  W A I S L E R  b. United States 1938

*Menorah,* 1975

Etching on ivory wove paper; watermark: ARCHES FRANCE; 1/100
60 x 91 cm (24 x 26)
Gift of the artist
76.24
*Lee Waisler* 24

Waisler was commissioned by the Magnes Museum to produce this etching. The menorah, one of the oldest Jewish ceremonial objects, signifies for Waisler the strength, power, and unity of the Jewish people.

S H L O M O   K A T Z    b. Poland 1937

*Adam and Eve*

Color screenprint on ivory wove paper; watermark: (BF)K RIVES; 11/75
96 x 74.5 cm (38 x 29 1/4)
Gift of Jacob F. Adler
75.270

Katz's bold outlines and juxtaposed patterns create a composition of unusual intensity and delight. *Adam and Eve* illustrates:

*And when the woman saw that the tree was good for food, and that it was a delight to the eyes, and that the tree was to be desired to make one wise, she took of the fruit thereof, and did eat; and she gave also unto her husband with her, and he did eat.* (Gen. 3:6)

ELIE  ABRAHAMI   b. Iran 1941

*Untitled,* 1980

Color lithograph on ivory wove paper; chop: EP; watermark: ARCHES FRANCE; 25/100
76 x 55 cm (30 1/4 x 22 1/4)
Gift of Mr. and Mrs. Harold Strom
81.59.1

Bizarre characters and mysteriously propelled odd objects in space are familiar symbolic
themes in Abrahami's art. The floating objects suggest the space within each of us that
requires dialogue and spiritual food for sustenance. Life and its continuity are represented
by the animal and the couple.

RUTH WEISBERG    b. United States 1942

*Family Remembrance*, 1975

Color lithograph on ivory wove paper; chop: winged oval; 18/20
42.2 x 49 cm (17 x 19 1/4)
Gift of the artist in memory of Alfred Weisberg
77.104

Weisberg explains that her art "rises from the powerful impulse to hold on to friends,
ancestors, the shared past. I see through a veil of time and memory. My art also reminds me
by its ephemeral paper presence of the illusionary nature of my possession of the past."

S T E P H A N I E   W E B E R    b. United States 1943

*Remembrance,* 1975

Etching and photoetching on cream wove Arches paper; A/P; edition of 50
55 x 76 cm (21 3/4 x 30 2/5)
Gift of the artist
75.349

Weber's collagelike composition incorporates images of family life — memories of her grandfather's Yiddish newspaper, *The Forward,* the warmth of a holiday dinner. She was commissioned by the Magnes Museum to produce this etching in celebration of the Bicentennial of the United States.

D A N I E L A   B A R N E A   b. Israel 1944

*Jerusalem,* 1973

Etching and aquatint on ivory wove paper; 1/50
24.5 x 20 cm (9 3/4 x 8)
Gift of the artist
74.46

*Jerusalem* was commissioned by the Magnes Museum to commemorate Israel's twenty-fifth anniversary and is a fine example of Barnea's technique of combining etching with aquatint to achieve rich contrasts of black and white tonalities. The image is the earthly Jerusalem ascending to the heavenly Jerusalem as one contemplates the Old City and the Western Wall.

# B  I  O  G  R  A  P  H  I  E  S

Biographies were compiled from information contained in specialized books and articles, and from the following: *Jewish Art, An Illustrated History* by Cecil Roth (Greenwich, Connecticut: New York Graphic Society, Ltd., 1971); *Encyclopaedia Judaica* (Jerusalem: Keter Publishing House, Ltd., 1971); *Dictionnaire des Peintures, Sculpteurs, Dessinateurs et Graveurs* by E. Benezit [known as Benezit] (Paris: Librairie Gründ, 1976); *Who's Who in American Art* (New York: R. R. Bowker Co., 1936-37, 1938-39, 1982); *Dictionary of Contemporary American Artists* by Paul Cummings (New York: St. Martin's Press, 1982). Material from Cummings was listed almost in its entirety for the following artists: Irving Amen, Harold Altman, Leonard Baskin, Joseph Floch, William Gropper, Chaim Gross, Jack Levine, Harold Paris, Abraham Rattner, Ben Shahn, Raphael Soyer, and Abraham Walkowitz.

ELIE ABRAHAMI Graphic artist, watercolorist, painter. b. 1941 Iran. Immigrated Israel, 1959. Moved to Paris 1970; EDUCATION/TRAINING: 1964-68 studied Tel Aviv School of Fine Arts. HONORS: First prize in painting, Paris Museum of Jewish Art, 1971; Honors Award, First International Engraving Biennial, Monaco, 1971. ONE-ARTIST EXHIBITIONS: Engel Gallery, Jerusalem, 1972; Graphic Arts Gallery, Tel Aviv, 1972; Bernier Gallery, Paris, 1973; Cité des Arts, Paris, 1974; Avoir Gallery, Tel Aviv, 1975; Graphic 3, Haifa, 1975; K Gallery, Lyon, France, 1975; Angle A Gallery, Brussels, 1978; Bernier Gallery, Paris, 1978; Atali Gallery, Paris, 1978; K Gallery, Lyon, France, 1979; International Monetary Fund, Washington, D.C., 1979; Gage Gallery, Washington, D.C., 1980; Sutton Gallery, New York, 1982; Judah Magnes Museum, 1983. GROUP EXHIBITIONS: Second International Engraving Biennial, Paris Museum of Modern Art, 1970; Second International Engraving Biennial, Galleria Museum, Paris, 1972; Print Exhibition, Tel Aviv Museum, 1973; Inlana Biennial, Florence, Italy, 1973; Collective Exhibition of Israeli Artists, Grand Palais Museum, Paris, 1977; Exhibition of French Artists and Engravers, Bibliotèque Nationale, Paris, 1980; Group Exhibition, Art West, Los Angeles, 1980; Group Exhibition, New York Art Exposition, New York, 1981. COLLECTIONS: National Fine Arts Museum, Paris; City of Paris Museum; Museum of Modern Art, New York; Guggenheim Museum, New York; Tel Aviv Museum, Israel; Israel Museum, Jerusalem; New York Public Library; Bibliotèque Nationale, Paris; Judah Magnes Museum. REFERENCES: Kaplan, Janice L. "The Captivating Color of Elie Abrahami." Washington, D.C.: *The Jewish Week,* July 12-18, 1979; conversation with Abrahami, Judah Magnes Museum, April 20, 1983; *Elie Abrahami.* Connecticut: Lubin Graphics, 1974.

JULES ADLER Painter, draftsman. b. 1865 France. d. 1952. EDUCATION/TRAINING: Student of Bouguereau, Robert-Fleury, and Dagnan-Bouveret; École des Beaux-Arts. MEMBER: Salon des Artistes Francais; Founding member Salon d'Automne. AWARDS: Silver medal, l'Exposition Universelle, 1900; diplôme d'honneur, l'Exposition Internationale, 1937; Prix Bonnat, 1938; Chevalier de la Legion d'Honneur, 1907. EXHIBITIONS: Pittsburgh; Brussels; Liège; Venice; Barcelona; Madrid; Munich; Tokyo; Salon des Tuileries, 1926. COLLECTIONS: Amiens; Bayeux; Besancon; Dijon; Douai; Gray; Lyon; Paris (Luxembourg); Petit Palais, Paris; Pau; Reims; New York; Chicago; Varsovie; Budapest; Buenos-Aires; Santiago; Tokyo; Judah Magnes Museum. REFERENCES: Benezit; *Jewish Art, An Illustrated History; Encyclopaedia Judaica.*

# B  I  O  G  R  A  P  H  I  E  S

HAROLD ALTMAN Printmaker, educator. b. 1924 United States. EDUCA-TION/TRAINING: Art Student's League (studied with George Bridgeman, Stefan Hirsch), 1941-42; Cooper Union (with Morris Kantor, Byron Thomas, Will Barnet), 1941-43, 1946-47; New School for Social Research (with Abraham Rattner), 1947-49; Black Mountain College (with Josef Albers), 1946; Académie de la Grande Chaumière (with McAvoy), 1949-52. TEACHING: New York State College of Ceramics; University of North Carolina; Indiana University; University of Wisconsin, 1956-62; Pennsylvania State University, 1962-. MEMBER: Society of American Graphic Artists, New York City; California Society of Printmakers; Print Council of America. COMMISSIONS (print editions): Museum of Modern Art, New York; Jewish Museum, New York; New York Hilton Hotel; Society of American Graphic Artists, New York; Container Corporation of America. AWARDS: Guggenheim Foundation Fellowship, 1961, 1963; National Institute of Arts and Letters, New York City, 1963; Art Institute of Chicago, John Taylor Arms Medal; Society of American Graphic Artists, New York; Pennsylvania Academy of the Fine Arts, Philadelphia; Tamarind Fellowship; Silvermine Guild; Fulbright-Hayes Research Scholar to France, 1964-65; Pennsylvania State University, 1968, 1969; Oklahoma Art Center, 1969. ONE-ARTIST EXHIBITIONS: Galerie Huit, Paris, 1951; Martha Jackson Gallery, 1958; Philadelphia Art Alliance, 1959, 1963; Peter H. Deitsch Gallery, 1960; Art Institute of Chicago, 1961; Museum of Modern Art, San Francisco, 1961; Santa Barbara Museum of Art, 1961; Escuela Nacional de Artes Plasticas, Mexico City, 1961; Goodman Gallery, Buffalo, 1961; Kasha Heman, Chicago, 1961, 1963; Felix Landau Gallery, 1962; Gump's Gallery, San Francisco, 1962, 1964; Irving Galleries, Inc., Milwaukee, 1962, 1964, 1966; Kenmore Galleries, Inc., Philadelphia, 1963; Pennsylvania State University, 1963; Kovler Gallery, 1963, 1966; A. B. Closson Gallery, Cincinnati, 1965; Weyhe Gallery, 1966; Oklahoma Art Center, 1966; Ohio State University, 1966; Franklin Siden Gallery, Detroit, 1966; Sagot-Le Garrec Gallery, Paris, 1968, 1974; Graphics Gallery, New York City, 1969, 1971; Haslem Fine Arts, Inc., 1970, 1971; David Barnett Gallery, Milwaukee, 1972; Gloria Luria Gallery, 1973; Gallery 1640, 1973; Marjorie Kauffman Gallery, Houston, 1973, 1974; Wustum Museum of Art, 1974; Impressions Workshop, Inc., 1975. GROUP EXHIBITIONS: Whitney Museum of American Art Annuals, New York; I Paris Biennial, 1959; Print Council of America, New York, 1959; The Society of American Graphic Artists, New York, 1960-74; Museum of Modern Art, New York, 1962; Festival of Two Worlds, Spoleto; St. Paul Gallery, 1962, 1964, 1966, 1971; Pennsylvania Academy of Fine Art Annuals, 1963, 1966, 1967, 1969; Metropolitan Museum of Art, Walter C. Baker Master Drawings Collection; Kunstmuseum, Basel, 1965; Museo Nacional de Bellas Artes, Santiago, Chile, II Interamerican Biennial of Printmaking, 1965; Whitney Museum of American Art, New York, 1965. COLLECTIONS: Achenbach Foundation for Graphic Arts, San Francisco; Stedelijk Museum, Amsterdam; Auburn University; Kunstmuseum, Basel; Bibliothèque Nationale; Bibliothèque Royale de Belgique Nationale; Boston Public Library; Boston University; Albright-Knox Art Gallery, Buffalo, New York; Art Institute of Chicago; Clairol, Inc.; Cleveland Museum of Art; Coca-Cola Company; Container Corp. of America; Statens Museum fur Kunst, Copenhagen; Detroit Institute of Arts; Escuela Nacional de Artes Plasticas, Mexico City; First National Bank of Dallas; First National Bank, Minneapolis; University of Georgia; University of Glasgow; Grinnell College; Grunwald Foundation; Museum of Modern Art, Haifa; Wadsworth Atheneum, Hartford, Connecticut; Hershey Foods Corp.; International Business Machines; University of Illinois; University of Kentucky; Library of Congress; De Cordova and Dana Museum, Lincoln, Massachusetts; Los Angeles County Museum of Art; Lytton Savings and Loan Association; Metropolitan Museum of Art, New York; Museum of Modern Art, New York; Malmo Museum, Malmo, Sweden; Milwaukee Art Center; Milwaukee Journal; New York Public Library; New York University; National Gallery, Washington, D.C.; Newark Museum; New York Hilton Hotel; Museum of Arts and Sciences, Norfolk, Virginia; Pennsylvania Academy of the Fine Arts, Philadelphia; Philadelphia Museum of Art; Pennsylvania State University; Philip

# B I O G R A P H I E S

Morris Collection; Princeton University; North Carolina Museum of Art, Raleigh; Art Institute of San Francisco; Smithsonian Institution; Syracuse University; Art Gallery of Greater Victoria, B.C., Canada; Whitney Museum of American Art, New York; Walker Art Center, Minneapolis, Minnesota; Woodward Foundation, Washington, D.C.; Yale University; Butler Institute of American Art, Youngstown, Ohio; Judah Magnes Museum. REFERENCES: *Dictionary of Contemporary American Artists; Who's Who in American Art.*

IRVING AMEN Painter, sculptor, printmaker. b. 1918 United States. EDUCATION/ TRAINING: Art Student's League; Studied with Vaclav Vytlacil, William Zorach, John Hovannes; Pratt Institute; Leonardo da Vinci Art School, New York City; Académie de la Grande Chaumière, 1950; Florence and Rome, Italy. TEACHING: Pratt Institute, 1961; University of Notre Dame, 1962. MEMBER: Artists Equity; Audubon Artists; Boston Printmakers; Society of American Graphic Artists, New York; Fellow of the International Institute of Arts and Letters, 1960. COMMISSIONS: A peace medal to commemorate the end of the Vietnam War. ONE-ARTIST EXHIBITIONS: New School for Social Research, 1948; Smithsonian Institution, 1949; Krasner Gallery, 1948; Nebraska Wesleyan University, Lincoln, 1969. GROUP EXHIBITIONS: United States Information Agency, *Contemporary American Prints,* circ. France, 1954; United States Information Agency, *20th Century American Graphics,* circ., 1959-61; Museum of Modern Art, New York, *Master Prints from the Museum Collection,* 1949; Museum of Modern Art, New York, *Young American Printmakers,* 1953; Metropolitan Museum of Art, *Graphic Arts,* 1955; University of Illinois, *50 Contemporary American Printmakers,* 1956; *ART:USA:59,* New York City, 1959; Library of Congress; Brooklyn Museum; IV Bordighera Biennial, 1957; Pennsylvania Academy of the Fine Arts, Philadelphia; National Academy of Design; Silvermine Guild; Audubon Artists; Society of American Graphic Artists, New York; American Color Print Society. COLLECTIONS: Israel Museum; Bibliothèque Nationale, Paris; Bibliothèque Royale de Belgique; Museum of Fine Arts, Boston, Massachusetts; Cincinnati Art Museum; Graphische Sammlung Albertina; Harvard University; Library of Congress; Metropolitan Museum of Art, New York City; Museum of Modern Art, New York City; New York Public Library; Philadelphia Museum of Art; Smithsonian Institution; Victoria and Albert Museum; Wilberfeld Archives; Judah Magnes Museum. REFERENCES: *Amen 1964-1968.* New York: Amen Galleries, Inc., 1968; *Irving Amen Woodcuts, 1948-1960.* Preface by Jacob Kainen. New York: Artists Studio, 1960; *Irving Amen.* New York: Amen Galleries, 1964; *Dictionary of Contemporary American Artists.*

ISIDORE ASCHHEIM Painter, graphic artist. b. 1891 Germany. d. 1968. Immigrated Palestine 1940. EDUCATION/TRAINING: Breslau Art Academy under Otto Mueller, a member of Die Brücke Group. TEACHING: Bezalel Academy of Arts and Design from 1943; Director Bezalel, 1959. AWARDS: Dizengoff Prize of Tel Aviv, 1953; Jerusalem Prize, 1955. EXHIBITIONS: Lugano; represented Israel in the Venice Biennale; Retrospective, Israel Museum, 1967. COLLECTIONS: Museum of Modern Art, New York City; Detroit Art Museum; Philadelphia Museum; Hebrew Union College Skirball Museum, Los Angeles; Judah Magnes Museum. REFERENCES: *Young and Old Masters of Israel,* Safrai Art Gallery, Judah Magnes Museum, 1968; *Encyclopaedia Judaica,* p. 690.

# B I O G R A P H I E S

W I L L I A M   A U E R B A C H - L E V Y   Painter, etcher, caricaturist. b. 1889 Poland. d. 1964. EDUCATION/TRAINING: College of the City of New York; National Academy of Design; Academie Julian, Paris, under Laurens. MEMBER: Society of American Etchers. TEACHING: Roerich Museum, New York, until 1937; author of many magazine articles on art; National Academy of Design; Educational Alliance, New York; COLLECTIONS: Art Institute of Chicago; Boston Museum of Fine Arts; Judah Magnes Museum; Maurice Spertus Museum of Judaica, Chicago. REFERENCES: *The Universal Jewish Encyclopedia.* Vol. I, pp. 612-613. New York, 1948; *Who's Who in American Art, 1936-37; New York Times* obituary, 30 June 1964, p. 33; Benezit; *100 Contemporary American Jewish Painters & Sculptors.* New York: YKUF Art Section, 1947, p. 122.

M A R T I N   B A E R   b. 1894 United States. d. 1961. EDUCATION/TRAINING: Art Institute of Chicago; Munich Art Academy, 1921-24; California School of Fine Arts. EXHIBITIONS: Palais de Glace de Munich, 1924; Salon d'Automne, Paris, 1928; St. Louis; Los Angeles; The Art Institute of Chicago, 1926, 1928, 1929. Galerie Jeune Peinture, Paris, 1928; California Palace of the Legion of Honor, 1943; Durand-Ruel's, Paris, 1926; California Palace of the Legion of Honor, San Francisco, 1963; Oakland Museum, California, 1979; North Point Gallery, San Francisco, 1979. COLLECTIONS: Musée d'Art Moderne, Paris; Museum of Modern Art, New York; Oakland Museum, California; San Diego Museum of Art, California; Fort Worth Museum, Texas; Los Angeles County Museum of Art, California; Judah Magnes Museum. REFERENCES: *The Art of Martin Baer George Baer.* New York: Newhouse Galleries, 1928; *Artforum.* Vol. I, No. 10, review by E. M. Polley, p. 14; *A Catalogue of Paintings by M. B. and George Baer.* The Art Institute of Chicago, MDCCCCXXVI; *Martin Baer.* San Francisco: California Palace of the Legion of Honor, 1963; Albright, Thomas. "Baer Paintings at Oakland Museum." *San Francisco Chronicle,* May 13, 1979, pp. 48-49.

M A X   B A N D   Painter. b. 1900 Lithuania. d. 1974. Moved to Paris 1925; Immigrated U.S. 1940. EDUCATION/TRAINING: Free Academy, Berlin; Kaiser Friedrich Museum, Berlin. PROFESSIONAL: Illustrated *Themes from the Bible,* 1964. EXHIBITIONS: Berlin galleries, 1924, 1929, 1931; Paris galleries, 1926, 1929, 1932; New York galleries, 1926, 1931; University of Kaunas, 1932; London; Amsterdam; Geneva; Salon des Tuileries, 1930-1939; Wildenstein Gallery; Israel Museum, Jerusalem. COLLECTIONS: Musée de Jeu de Paume, Paris; Tel Aviv Museum; Israel Museum, Jerusalem; Los Angeles County Museum of Art; Jüdisches Museum de Berlin; Roerich Museum, New York; Musées de Kaunas; Toledo; Philadelphia; Judah Magnes Museum; Hebrew Union College Skirball Museum, Los Angeles. REFERENCES: George, W. *Max Band* (Fr. 1932); Fierens, P. *Max Band* (Fr. 1935); Millier, A. *The Art of Max Band.* Los Angeles: Borden Publishing Company, 1945; Benezit; *100 Contemporary American Jewish Painters and Sculptors.* New York: YKUF Art Section, 1947.

# B I O G R A P H I E S

D A N I E L A  B A R N E A  Graphic artist, book cover designer, book and poster illustrator. b. 1944 Israel. EDUCATION/TRAINING: Bezalel Academy of Arts and Design, B.A. School of Graphic Arts, 1966; Laney College Art Department, 1971-76; California College of Arts and Crafts, 1979-80. AWARDS: Israeli-American Annual Art Exhibition Award for Study with graphic design company in Zurich, Switzerland, 1968; first and second prizes in competition to design emblem for the new Diplomat Hotel in Jerusalem, 1970; grand prize for etchings *Jerusalem* and *Mount Zion,* Special Israel 28th Anniversary Art Show, San Jose, Calif., 1976. COMMISSIONS: Book covers and illustrations for children's books and posters in Israel and the United States; etching, *Jerusalem,* to commemorate 25th anniversary of Israel, by Judah Magnes Museum; EXHIBITIONS: Judah Magnes Museum, 1974; Art Co-op Gallery, Berkeley, 1975, 1976; Jewish Community Center, San Francisco, 1976; Hilton Hotel Art Gallery, Jerusalem, 1977, 1980; Gallery Judaica, Los Angeles, 1982, 1983; Judaic Art Exhibit (National Council on Art in Jewish Life), New York, 1983. COLLECTIONS: Judah Magnes Museum. REFERENCES: Artist's file, Judah Magnes Museum.

L E O N A R D  B A S K I N  Painter, sculptor, graphic artist, book illustrator. b. 1922 United States. EDUCATION/TRAINING: New York University, 1939-41; Yale University, 1941-43; New School for Social Research, M.A., 1949; Académie de la Grande Chaumière, 1950; Academy of Fine Arts, Florence, Italy, 1951; privately with Maurice Glickman. TEACHING: Worcester Museum School, 1952-53; Smith College, 1953-74. Operates the Gehenna Press. AWARDS: Prix de Rome, Honorable Mention, 1940; L. C. Tiffany Grant, 1947; Library of Congress, Pennell Purchase Prize, 1952; Guggenheim Foundation Fellowship, 1953; Society of American Graphic Artists, New York, Mrs. A. W. Erickson Prize, 1953; National Museum of Modern Art, Tokyo, O'Hara Museum Prize, 1954; University of Illinois, Purchase Prize, 1954; Art Institute of Chicago, Alonzo C. Mather Prize, 1961; VI São Paulo Biennial, 1961; American Institute of Graphic Art, Medal of Merit, 1965; Pennsylvania Academy of Fine Arts, Philadelphia, Gold Medal, 1969; National Institute of Arts and Letters, New York, Gold Medal, 1969. ONE-ARTIST EXHIBITIONS: Glickman Studio, 1939; Numero Galleria d'Arte, Florence, Italy, 1951; Little Gallery, Provincetown, Mass., 1952; Mount Holyoke College, 1952; Fitchburg Art Museum, Fitchburg, Massachusetts, 1952; Boris Mirski Gallery, Boston, 1954, 1955, 1956, 1964, 1965; Grace Borgenicht Gallery, Inc., 1954, 1960, 1964, 1966, 1969; Print Club, Philadelphia, 1956; Portland Museum of Art, Portland, Maine, 1956; Wesleyan University, 1956; University of Minnesota, 1961; University of Louisville, 1961; Museum Boymans Van Beuningen, Rotterdam, Holland, 1961; Amerika Haus, Berlin, 1961; American Cultural Center, Paris, 1961; Royal Watercolor Society, London, 1962; Peale House, Philadelphia, 1966; FAR Gallery, 1970; National Collection of Fine Arts, Washington, D.C., 1970; A. Lublin, Inc., New York City, 1970; Kennedy Gallery, New York City, 1971, 1973, 1974, 1975, 1976, 1978; Amon Carter Museum, 1972; Jewish Museum, New York, 1974; Summit, New Jersey, Art Center, 1974; San Francisco Museum of Art, 1976; Indianapolis Museum of Art, Indiana, 1976; Towson State College, Baltimore, 1976; Port Washington, New York, Public Library, 1977; Washington University, 1978. RETROSPECTIVES: Bowdoin College, 1962; Smith College, 1963; Worcester Art Museum, Mass., 1957. GROUP EXHIBITIONS: Museum of Modern Art, New York; Whitney Museum of American Art, New York; Brooklyn Museum, 1949, 1952, 1953, 1954, 1955; Library of Congress; Print Club, Philadelphia; Society of American Graphic Artists, New York, 1952, 1953; São Paulo; Brandeis University; Seattle Art Museum. COLLECTIONS: Allegheny College; Auburn

# B I O G R A P H I E S

University; Baltimore Museum of Art; Israel Museum; Museum of Fine Arts, Boston; Bowdoin College; Brandeis University; Brooklyn Museum; Albright-Knox Art Gallery, Buffalo, New York; Amon Carter Museum; Chase Manhattan Bank; Art Institute of Chicago; University of Delaware; Detroit Institute of Arts; Fitchburg Art Museum, Massachusetts; Harvard University; Hirshhorn; Holyoke Public Library; University of Illinois; Library of Congress; Metropolitan Museum of Art, New York; Museum of Modern Art, New York; Mount Holyoke College; New York Public Library; National Academy of Sciences; National Gallery; University of Nebraska; Newark Museum; New School for Social Research; Joslyn Art Museum, Omaha; Pennsylvania Academy of the Fine Arts, Philadelphia; Philadelphia Museum of Art; Princeton University; Print Club, Philadelphia; Smithsonian Institution; St. John's Abbey, Collegeville, Minnesota; City Art Museum of St. Louis; Seattle Art Museum; Skidmore College; Smith College; New Jersey State Museum, Trenton; Munson-Williams-Proctor Institute, Utica, New York; Whitney Museum of American Art, New York; Wesleyan University; Worcester Art Museum, Worcester, Massachusetts; Judah Magnes Museum. REFERENCES: Johnson, Una E. *American Prints and Printmakers.* New York: Doubleday & Co., Inc., 1980, pp. 69, 126; *Leonard Baskin, His Graphic Art 1952-1963.* Duke University, 1963; *Leonard Baskin, Sculpture, Drawings, Woodcuts.* Massachusetts: Worcester Art Museum, 1957; *Leonard Baskin, Ten Woodcuts.* Printed for R. M. Light & Co. Massachusetts: Gehenna Press, 1961; *Leonard Baskin, The Northampton Years.* Massachusetts: Cornell Galleries; *Dictionary of Contemporary American Artists.*

J O S E P H   B U D K O   Graphic artist, book illustrator. b. 1888 Poland. d. 1941. Immigrated Palestine 1933. EDUCATION/TRAINING: Berlin, 1910; Academy of Fine Arts, Vilna; influenced by Hermann Struck in graphic arts. TEACHING: Bezalel Academy of Arts and Design, Jerusalem; Director 1935-40. EXHIBITIONS: Hebrew Union College Skirball Museum, Los Angeles, 1966, 1983; COLLECTIONS: Israel Museum, Jerusalem; Judah Magnes Museum; Tel Aviv Museum; Hebrew Union College Skirball Museum, Los Angeles; Maurice Spertus Museum of Judaica, Chicago. REFERENCES: *Encyclopaedia Judaica;* Schwarz, Karl. *Jewish Artists of the 19th and 20th Centuries.* New York: Philosophical Library, Inc., 1949; Friedberger, Hans. *"J.B." Judische Bucherei, No. 19;* Schwarz, Karl. *Die Juden in der Kunst,* 1928.

M A R C   C H A G A L L   Painter, graphic artist, book illustrator, theatrical set and costume designer, muralist, stained glass window designer. b. 1887 Russia. EDUCATION/ TRAINING: Studied with Jehuda Pen, Vitebst, 1907; Imperial Society of Fine Arts; Leon Bakst's school Svanseva; La Paletta and La Grande Chaumière, Paris. TEACHING/ PROFESSIONAL: Commissar of Fine Arts, Director of Vitebst Academy, 1918. MURALS: Kamerny State Jewish Theatre, Moscow, 1920; Watergate Theatre, London, 1949; Frankfurt Theatre, 1959; decorated auditoriums, Tokyo, Tel Aviv, 1964; Murals, Parliament, Jerusalem, 1966; Maeght Fondation, St. Paul, 1969; ceiling Paris Opera, 1962. SET AND COSTUME DESIGNS: "The Miniatures," by Sholem Aleichem, 1920; ballets Aleko, 1942; Firebird, 1945; Daphnis and Chloe, 1958. STAINED GLASS WINDOWS: Metz Cathedral, 1960; Hadassah Medical Center, Jerusalem, 1962; Reims Cathedral, 1974. BOOKS ILLUS-TRATED: *The Bible; Fables* by La Fontaine; *Dead Souls* by Nicholai Gogol. AWARDS: Carnegie Prize, 1939; Grand Cross, Legion of Honor, 1977. RETROSPECTIVES: Galerie

# B    I    O    G    R    A    P    H    I    E    S

Barbazanges-Hodebert, Paris, 1924; Kunsthalle, Berlin, 1933; Museum of Modern Art, New York, 1946; Musée National d'Art Moderne, Paris, 1947; Paris, Munich, Hamburg, 1959; Pierre Matisse Gallery, 1968; Grand Palais, Paris, 1970; Le Musée National du Message Biblique Marc Chagall, Nice, inaugurated 1973. EXHIBITIONS: Salon des Indépendants and Salon d'Automne, 1912; Moscow Art Salon, 1913, 1915; Dobitchina Gallery, St. Petersburg, 1917; Basel Museum, 1933; Galerie Mai, Paris, 1940; Pierre Matisse Gallery, New York, 1941; Stedelijk, Amsterdam; Tate, London; Kunsthaus, Zurich; Kunsthalle, Bern, 1947; Jerusalem Museum, 1951; Bibliothèque Nationale, Paris, 1957; Musée des Arts Decoratifs, Paris, 1959; Museum of Modern Art, New York, 1961; Tokyo National Museum, 1963; 80th birthday retrospectives, 1967, in Zurich, Cologne, Louvre, Maeght Fondation, France; Grand Palais, Paris, 1969; Bibliothèque Nationale, Paris, 1970; Tretyakov Gallery, Moscow, 1973; National Gallery, East Berlin, 1974; Pierre Matisse Gallery, New York, 1970. COLLECTIONS: Municipal Museum, Amsterdam; Kunstmuseum Bale; Kunsthalle, Bern; Art Institute of Chicago; Wallraf-Richartz Museum, Cologne; Dusseldorf Museum; Van Abbe Museum, Eindhoven; State Museum Russia, Leningrad; Museum des Beaux-Arts, Liège; Tate Gallery, London; Tretyakov, Moscow; Museum of Modern Art, New York; Guggenheim Foundation, New York; Musée d'Art Moderne, Paris; Musée Municipale de la Ville, Paris; Philadelphia Museum of Art; San Francisco Museum of Modern Art; Judah Magnes Museum. REFERENCES: Sorlier, Charles. *Chagall by Chagall.* New York: Harry N. Abrams, Inc., 1979; Sorlier, Charles, and Fernand Mourlot. *Chagall Lithographe 1969-1973.* Monte Carlo: Editions André Sauret, 1974; Benezit.

BORIS DEUTSCH   Painter, watercolorist, draftsman. b. 1892 Russia. d. 1978. Immigrated U.S. 1916. EDUCATION/TRAINING: Bloom Academy, Riga; Berlin academies. EXHIBITIONS: Los Angeles Museum, 1926; University of California, 1926, 1942, 1947; Los Angeles Museum, 1929, 1941; East West Gallery, San Francisco, 1929; California Art Club, 1929; Mills College, Oakland, 1929; Seattle Art Institute, 1930; San Diego Museum, 1930; Denver Museum, 1931; Portland Museum, 1931; Berkeley Museum, 1931; California Palace of the Legion of Honor, San Francisco, 1931; Dallas Museum, Texas, 1932; Jacques Selligman, New York, 1933; Oakland Art Gallery, 1936, 1940; Scripps College, Claremont, 1946; Cowie Galleries, Los Angeles, 1947. COLLECTIONS: California Palace of the Legion of Honor; Mills College, Oakland; Portland Museum; Carnegie Institute, Pittsburg, Pennsylvania; Denver Museum; Judah Magnes Museum; Hebrew Union College Skirball Museum, Los Angeles; Maurice Spertus Collection of Judaica, Chicago. REFERENCES: *Boris Deutsch.* June 2 to June 21, 1974. Cowie Galleries, Los Angeles.

HERMANN FECHENBACH   Painter, graphic artist, draftsman. b. 1897 Germany. Immigrated England 1939. Settled Oxford 1941. EDUCATION/TRAINING: Art academies in Stuttgart, Munich, Florence, Vienna, 1919-26. EXHIBITIONS: Oxford, England, 1942. COLLECTIONS: Judah Magnes Museum. REFERENCE: *Genesis: The First Book of Moses — Wood Engravings by Hermann Fechenbach.* London & Oxford: A. R. Mowbray & Co., Ltd., 1969.

# B  I  O  G  R  A  P  H  I  E  S

FRIEDRICH FEIGL Painter, graphic artist, book illustrator. b. 1884 Czechoslovakia. d. 1966. Immigrated London 1943. EDUCATION/TRAINING: Studied Prague, Paris. PROFESSIONAL: Chairman, Prague Secession; Chairman "Freie Bewegung," Vienna. EXHIBITIONS: Lefevre Gallery, London, 1943. COLLECTIONS: Judah Magnes Museum; Hebrew Union College Skirball Museum, Los Angeles. REFERENCES: Marzynski, G. *Friedrich Feigl.* Germany, 1921; *Encyclopaedia Judaica.*

JOSEPH FLOCH Painter, draftsman. b. 1895 Austria. d. 1977. Resided Paris twenty years. Immigrated U.S. 1941. EDUCATION/TRAINING: Academy of Fine Arts, Vienna, M.A. TEACHING: New School for Social Research. MEMBER: Federation of Modern Painters and Sculptors; National Academy of Design; Salon d'Automne, Paris; Salon des Tuileries, Paris. COMMISSIONS: French Government, 1939 (murals); costumes and stage sets (with Louis Jouvet) for the Jean Giraudoux play *Judith.* AWARDS: Chevalier of the Order of Arts and Letters; Paris World's Fair, 1937, Gold Medal; William Palmer Memorial Prize; Pennsylvania Academy of Fine Arts, Philadelphia, Walter Lippincott Prize; Eastern States exhibit, Springfield, Massachusetts, 1966; National Academy of Design, Saltus Gold Medal for Merit, 1967. ONE-ARTIST EXHIBITIONS: (first) a gallery in Vienna, 1917; Galerie Berthe Weill, Paris; A.A.A. Gallery, New York City; Toledo Museum of Art; M. H. de Young Museum, San Francisco; Syracuse University, 1965; Forum Gallery (three-man), 1975. RETROSPECTIVE: Belvedere, 1972. GROUP EXHIBITIONS: Metropolitan Museum of Art, New York; Whitney Museum of American Art, New York; New York World's Fair, 1939; Paris World's Fair, 1937. COLLECTIONS: Osterreichische Galerie im Belvedere, Vienna; Israel Museum; M. H. de Young Museum, San Francisco; Graphische Sammlung Albertina; Musée des Beaux-Arts de Grenoble, France; William Rockhill Nelson Gallery of Art, Kansas City, Missouri; Palais des Beaux Arts, Lille, France; Metropolitan Museum of Art, New York; Museum of Modern Art, New York; Montclair Art Museum, Montclair, New Jersey; Musée du Jeu de Paume, Paris; Musée d'Art Moderne de la Ville de Paris; Smithsonian Institution; Parrish Museum, Southampton, New York; Museum of Fine Arts, Springfield, Mass.; Tel Aviv Museum, Israel; Toledo Museum of Art, Toledo, Ohio; Museen der Stadt Wien, Austria; Whitney Museum of American Art; Judah Magnes Museum. REFERENCES: *Jewish Art, An Illustrated History; Dictionary of Contemporary American Artists.*

ALBERT GARVEY Printmaker, sculptor. b. 1932 United States. EDUCATION/TRAINING: Chicago Academy of Fine Arts; Art Institute of Chicago; University of California, Los Angeles; Otis Art Institute; L'École Nationale Superieure des Arts Decoratifs, Paris; Studio of Nicolai Fechin, Los Angeles. PRIZES: Edition 1971, Walnut Creek, Calif.; Colorprint USA, Texas Tech University; Marin County Fair; Bay Area Printmakers, De Anza College; Crocker-Kingsley Annual, Crocker Gallery Purchase Prize. NATIONAL AND INTERNATIONAL EXHIBITIONS: *Seattle Print International,* 1971; *Edition 1971,* Walnut Creek, Calif.; Oklahoma Art Center, *13th and 14th National Exhibitions of Prints and Drawings,* 1971, 1972; *Colorprint, USA,* Texas Tech University, 1971; *Northwest Printmakers International,* 1969; *Boston Printmakers,* 1970; *Los Angeles Society of Printmakers,* 1969, 1972; *Ultimate Concerns,* Ohio University, 1966; Atlanta, Georgia, *3rd Annual National Print Exhibition,* 1972; *North Dakota 14th Annual Print and Drawing Exhibition,* 1971. ONE-ARTIST EXHIBITIONS: University of California, Santa Cruz; Shelby Galleries,

# B I O G R A P H I E S

Sausalito, California; Walnut Creek Civic Arts Print Gallery, California; Marin Museum Society, Marin County Civic Center, California; Studio Gallery, Geneva, Illinois; Gallery III, Corte Madera, California; Marin Unitarian Fellowship, San Rafael, California; Artists' Galleries, Wyncote, Pennsylvania. OTHER EXHIBITIONS: California State Fair, Calexpo, 1971; Marin County Fair, 1971, 1972; Northern California Arts 18th Annual Open Art Exhibition, 1971; Crocker-Kingsley 47th Annual Art Show, Sacramento, Calif., 1972; Bay Area Printmakers, De Anza College, Cupertino, 1972. COLLECTIONS: Oakland Museum; E. B. Crocker Gallery, Sacramento, California; Texas Tech University; De Anza College, Cupertino, California; City of Sausalito, California; Judah Magnes Museum. REFERENCES: Artist's file, Judah Magnes Museum.

LEOPOLD GOTTLIEB Painter, draftsman. b. 1883 Poland. d. 1934. Immigrated Paris. EDUCATION/TRAINING: Cracow Academy and Munich; influenced by impressionism; studied in Paris; won prize, Varsovie, 1904. TEACHING: Bezalel Academy of Arts and Design, Jerusalem, short time. EXHIBITIONS: Salon d'Automne, 1908, 1913; Salon des Indépendants and La Société Nationale, 1910-12; Exposition de la Secession, Vienna, 1920; Maurice Spertus Collection of Judaica, Chicago, *The French Connection: Jewish Artists in the School of Paris,* 1983. COLLECTIONS: Museum of Cracow; Israel Museum, Jerusalem; Rapperswil Museum, Switzerland; Judah Magnes Museum. REFERENCES: *Jewish Art, An Illustrated History;* Benezit.

YITZHAK GREENFIELD Painter, graphic artist. b. 1932 United States. Immigrated Israel 1951. EDUCATION/TRAINING: Educational Alliance Art School, New York; Venice with artist and printmaker Borin; art workshops, Israel, taught by Marcel Yanco, Yochanan Simon and Wexler. AWARDS: Dizengoff Art Award, 1956; American-Israel Culture Fund study grant, 1961. TEACHING: Kibbutz Gat-Galon; H. S. Judean Hills, Regional School; Art Workshops for Gifted Youth, Ministry of Education, Jerusalem; Anglican School, Jerusalem; Bet Haam Peoples University, Jerusalem; Youth Wing Israel Museum, Jerusalem; Frontline lecturer on art, Israel Defense Forces; lecture series, Israeli Art, The Herzl Institute, New York; Onienta State College, New York. COMMISSIONED WORKS AND SPECIAL PROJECTS: "Pray for the Peace of Jerusalem," a mural for the Israel Ministry of Communications presented to the International Telecommunication Union, Geneva, Switzerland; mural for public school, Katamon, Jerusalem; special poster for Middle East and Archaeology Department, Brooklyn Museum; etching, *Jerusalem,* for Judah Magnes Museum. EXHIBITIONS: Chemerinsky Gallery, Tel Aviv, 1959; Old Artists' House, Jerusalem, 1960; 11 Torchio Gallery, Venice, 1961; Bet Chagall, Haifa, 1962; Bet Wilfred Museum, Kibbutz Hazorea, 1963; New Artists House, Jerusalem, 1967; Ber Sheva Museum, 1967; Old Jaffa Gallery, 1970; Gallery M., Jerusalem, 1972; He-Atid Graphic Gallery, Jerusalem, 1972; Rennee Darom Gallery, Tel Aviv, 1972; S. Wise Congress House, New York, 1975; Elicofen Art Gallery, New York, 1975; Onienta State College, New York, 1975; Judah Magnes Museum, 1975. COLLECTIONS: Israel Museum, Jerusalem; Tel Aviv Museum, Israel; Museum of Modern Art, New York; Museum of Modern Art, Haifa, Israel; Museum of Ber Sheva, Israel; Sheldon Swope Art Gallery, Terre Haute, Indiana; City College of New York; Bibliothèque Nationale, Paris; Brooklyn Museum, New York; Hebrew Union College Skirball Museum, Los Angeles; Judah Magnes Museum. REFERENCES: Artist's file, Judah Magnes Museum.

# B  I  O  G  R  A  P  H  I  E  S

WILLIAM GROPPER  Painter, graphic artist, cartoonist. b. 1897 United States. d. 1977. EDUCATION/TRAINING: Ferrar School, with Robert Henri, George Bellows, 1912-13; National Academy of Design, 1913-14; New York School of Fine and Applied Art, with Howard Giles, Jay Hambridge, 1915-18. Staff Artist, *New York Tribune,* 1919-21, *New York World,* 1925-27. TEACHING: American Art School, New York City, 1946-48. MEMBER: Artists Equity; National Institute of Arts and Letters, New York City, 1968; National Academy of Design. COMMISSIONS: New Interior Building, Washington, D.C.; Northwestern Postal Station, Detroit; U.S. Post Office, Freeport, New York; Schenley Industries, Inc., New York City. AWARDS: Young Israel Prize; Los Angeles County Museum of Art purchase prize; John Herron Art Institute, Indianapolis, Prize for Lithography; *Collier's* (magazine) Prize for Illustration, 1920; Harmon Foundation Award, 1930; J. S. Guggenheim Fellowship, 1937; Carnegie, Third Prize; Metropolitan Museum of Art, New York City, Artists for Victory, Lithography Prize, 1942; Tamarind Fellowship, 1967; National Academy of Design, Thomas B. Clarke Prize, 1973, Andrew Carnegie Prize, 1975. RETROSPECTIVES: Phoenix Art Museum, Arizona; Evansville Museum of Arts and Sciences, Indiana; Palm Springs Desert Museum; Syracuse University; University of Miami, *50 Years of Drawing and Cartoons,* circulated 1968. GROUP EXHIBITIONS: Metropolitan Museum of Art, New York; Whitney Museum of American Art, New York City; Art Institute of Chicago; The Museum of Modern Art, New York City; Los Angeles County Museum of Art. COLLECTIONS: Abbott Laboratories; University of Arizona; Brandeis University; Encyclopaedia Britannica; Canton Art Institute; Art Institute of Chicago; Cornell University; Evansville Museum of Arts and Sciences, Indiana; Wadsworth Atheneum, Hartford, Connecticut; Harvard University; Hirshhorn Museum and Sculpture Garden, Smithsonian Institution; Library of Congress; Los Angeles County Museum of Art; Metropolitan Museum of Art, New York; Museum of Modern Art, New York; Montclair Art Museum, Montclair, New Jersey; Museum of Western Art, Moscow, USSR; New York Public Library; Newark Museum; Pennsylvania Academy of the Fine Arts, Philadelphia; Phillips Gallery, Washington, D.C.; City Art Museum of St. Louis, Missouri; National Museum, Sofia, Bulgaria; Storm King Art Center, Mountainville, New York; Syracuse University; Tate Gallery, London; University of Tucson; Whitney Museum of American Art; Walker Art Center, Minneapolis, Minnesota; Butler Institute of American Art, Youngstown, Ohio; Judah Magnes Museum. REFERENCES: Freundlich, A. L. *William Gropper Retrospective,* 1968; *Encyclopaedia Judaica;* Lozowick, Louis. *William Gropper.* Philadelphia: The Art Alliance Press, 1983; Gahn, Joseph Anthony. *The America of William Gropper, Radical Cartoonist.* Syracuse University, Ph.D., 1966, University Microfilms, Inc., Ann Arbor, Michigan; Benezit; Albright, Thomas. "The Art of William Gropper." *San Francisco Chronicle,* March 20, 1983.

CHAIM GROSS  Sculptor, painter, watercolorist, graphic artist. b. 1904 East Austria. Immigrated United States 1921. EDUCATION/TRAINING: Kunstgewerbe Schule, Vienna; Educational Alliance, New York; Beaux-Arts Institute of Design, with Elie Nadelman; Art Students League, New York, with Robert Laurent. TEACHING: Educational Alliance, New York; New School for Social Research. MEMBER: Sculptors Guild (President); Artists Equity; Federation of Modern Painters and Sculptors; National Institute of Arts and Letters, New York. Federal A. P.: Teacher, supervisor, sculptor. COMMISSIONS: Main Post Office, Washington, D.C., 1936; Federal Trade Commission Building, Washington, D.C., 1938; France Overseas Building, New York World's Fair, 1939; U.S. Post Office, Irwin, Pennsylvania, 1940; Reiss-Davis Child Guidance Clinic, Beverly Hills, 1961;

# B I O G R A P H I E S

Hadassah Hospital, Jerusalem, 1964; Temple Shaaray Tefila, New York, 1964; University of Rhode Island, 1972; International Synagogue, Kennedy International Airport, 1972. AWARDS: L. C. Tiffany Grant, 1933; Paris World's Fair, 1937, Silver Medal; Metropolitan Museum of Art, New York, Artists for Victory, $3,000 Second Prize, 1942; Boston Arts Festival, Third Prize for Sculpture, 1954; Pennsylvania Academy of the Fine Arts, Philadelphia, Honorable Mention, 1954; Audubon Artists, Prize for Sculpture, 1955; National Institute of Arts and Letters, New York, Grant, 1956; Boston Arts Festival, First Prize, 1963; National Institute of Arts and Letters, Award of Merit Medal, 1963; Honorary DFA, Adelphi University, 1980; Honorary DHL, Yeshiva University, 1978. ONE-ARTIST EXHIBITIONS: Gallery 144, New York, 1932; Boyer Gallery, Philadelphia, 1935; Boyer Gallery, New York, 1937; A.A.A. Gallery, New York, 1942, 1969; Massillon Museum, Akron Art Institute, Ohio, 1946; Butler Institute of American Art, Youngstown, Ohio, 1946; State University of New York, at New Paltz, 1952; Jewish Museum, New York, 1953; Shore Studio, Boston, 1954; Muriel Latow Gallery, Springfield, Massachusetts, 1956; Duveen-Graham Gallery, New York, 1957; Whitney Museum of American Art, New York, circulated, 1959; Marble Arch Gallery, Miami Beach, 1961; Anna Werbe Gallery, Detroit, 1962; Forum Gallery, 1962, 1964, 1967, 1972, 1973, 1974, 1977, 1980; Irving Galleries, Inc., Milwaukee, 1963; New School for Social Research, 1971; National Collection of Fine Arts, Washington, D.C., 1974; Leonard Hutton Gallery, New York, 1974; University of Miami, Florida, 1977; Montclair Art Museum, New Jersey, 1977; Jewish Museum, New York, 1977; Prince Arthur Galleries, Toronto, 1977. GROUP EXHIBITIONS: Whitney Museum of American Art Sculpture Annuals; Sculptors Guild Annuals; Pennsylvania Academy of the Fine Arts, Philadelphia; American Federation of Arts, New York, *Sculpture in Wood,* circulated 1941, 1942; *American Painting and Sculpture,* Moscow, 1959; Museum of Modern Art, New York, *The Making of Sculpture,* circulated 1961-1962; Smithsonian, *Drawings by Sculptors,* circulated, USA, 1961-1963; New York World's Fair, 1964-1965. COLLECTIONS: Ein-Harod, Israel; Phillips Academy, Addison Gallery of American Art, Massachusetts; Atlanta Art Association, Georgia; Baltimore Museum of Art, Maryland; Israel Museum; Museum of Fine Arts, Boston; Brandeis University; Brooklyn Museum; Bryn Mawr College; Art Institute of Chicago; Colby College; Dayton Art Institute, Ohio; Des Moines Art Center, Iowa; Fairleigh Dickinson University; University of Georgia; Museum of Modern Art, Haifa; Jewish Museum, New York; Kalamazoo Institute of Arts, Michigan; William Rockhill Nelson Gallery of Art, Kansas City, Missouri; Museum of Art, La Jolla, Calif.; Metropolitan Museum of Art, New York; Museum of Modern Art, New York; Massillon Museum, Ohio; Milwaukee Art Center, Wisconsin; University of Minnesota; Newark Museum, New Jersey; Ogunquit Museum of Art, Maine; Pennsylvania Academy of the Fine Arts, Philadelphia; Philadalphia Museum of Art, Pennsylvania; Phoenix Art Museum; Queens College, New York; Reading Public Museum and Art Gallery, Pennsylvania; Reed College; Rutgers University; Everhart Museum, Scranton, Pennsylvania; Scripps College; Smith College; Tel Aviv Museum of Art, Israel; Whitney Museum of American Art, New York; Walker Art Center, Minneapolis, Minnesota; Norton Gallery and School of Art, West Palm Beach, Florida; Worcester Art Museum, Massachusetts; Butler Institute of American Art, Ohio; Judah Magnes Museum. REFERENCES: Lombardo, Joseph Vincent. *Chaim Gross, Sculptor.* New York: Dalton House, 1949; Werner, Alfred. *Chaim Gross, Watercolors and Drawings.* New York: Harry N. Abrams, Inc., 1973; *Dictionary of Contemporary American Artists.*

# B I O G R A P H I E S

**AL HIRSCHFELD** Graphic artist, caricaturist. b. 1903 United States. EDUCATION/TRAINING: Art Students' League; National Academy School; from 1924 to 1938 went to Paris every other year. PROFESSIONAL: Caricatures first appeared in the *Old World,* 1923, followed by *The Tribune, Times, Holiday, Vanity Fair, Vogue, Colliers, Saturday Evening Post, Life, Look, Saturday Review, Argosy, Pic* and many others. Best known for caricatures of theatrical personalities appearing in Sunday edition of the *New York Times* since 1925. RETROSPECTIVES: *Fifty Years in the Arts,* Judah Magnes Museum, 1974; number of retrospectives celebrated Hirschfeld's 80th birthday June 1983; major show at Harvard's Fogg Art Museum, 1983. COLLECTIONS: Metropolitan Museum of Art, New York; Museum of Modern Art, New York; Brooklyn Museum; New York Public Library; Judah Magnes Museum. REFERENCES: Hirschfeld, Al, and Brooks Atkinson. *The Lively Years 1920-1973; Time,* "People" section. November 8, 1982, p. 53; *Art News,* April 1975; *Margo Feiden Galleries.* New York, 1973.

**JOZEF ISRAELS** Painter, draftsman, watercolorist. b. 1828 The Netherlands. d. 1911. EDUCATION/TRAINING: Amsterdam Academy of Fine Arts at age 17. Influenced by Barbizon School of Painters, France; Courbet, Millet, and Rembrandt. Studied three years in Paris 1845-1848; visited studios of Delacroix, Vernet, Pradier; true teacher was Picot. AWARDS: Third medal and decoration, Legion of Honor, 1867; first class medal and an officer of the Legion of Honor, Exposition 1878, Paris. Elected member of l'Institut de France, 1885. EXHIBITIONS: Salon de Paris, 1855. Exhibited in Paris, London, Berlin, New York, Vienna, Rome and Brussels. COLLECTIONS: National Museum, Amsterdam; Municipal Museum, Amsterdam; Glasgow; Musee Communal, Musee Mesdag, The Hague; National Gallery, London; Montreal; Tretiakoff, Moscow; Munich, Dordrecht Museum; Judah Magnes Museum. REFERENCES: *Encyclopaedia Judaica;* Benezit; *Jewish Art, An Illustrated History;* Eisler, Dr. Max. *Josef Israels.* London: The Studio, Ltd., 1924; Hubert, H. J. *De Etsen, Van Jozef Israels Een Catalogues.* Amsterdam: Scheltema En Holkemas' Boekhandel.

**SHLOMO KATZ** Graphic artist, illustrator. b. 1937 Poland. Immigrated Israel 1945. EDUCATION/TRAINING: Studied at the Avni Academy of Art, Tel Aviv, 1960; École des Beaux-Arts, Paris, 1962-64. PROFESSIONAL: Illustrated Haggadah published in limited edition with 13 colored illustrations. EXHIBITIONS: United States; Canada; Judah Magnes Museum, 1979. COLLECTIONS: Hillel House, London; Ben Uri collection, London; Jewish Community Center, Cincinnati, Ohio; Hebrew Union College, Cincinnati, Ohio; the city of Ottawa; Judah Magnes Museum. REFERENCES: Artist's file, Judah Magnes Museum.

# B I O G R A P H I E S

M O I S E   K I S L I N G   Painter. b. 1891 Poland. d. 1952. Immigrated Paris 1910. EDU-CATION/TRAINING: Academy of Fine Arts, Cracow; influenced by Cezanne. Studied with painter Pankiewicz. Friend of Modigliani, Derain and writers Max Jacob, Jean Cocteau and Raymond Radiguet. EXHIBITIONS: Russia and Germany, 1912-13; London, Stockholm, Sweden, 1917; Gloria Drau Gallery, Paris, 1919; Salon d'Automne, Paris; Salon des Tuileries, Paris; Whitney Museum of American Art, New York. From 1941-46 lived in U.S. COLLECTIONS: Barnes Foundation, Philadelphia; Belgrade; Brooklyn; Lisbon; Los Angeles; Musée de Longchamps, Marseille; Moscow; Musée d'Art Moderne, Paris; Stock-holm; Tel Aviv; Venice; Judah Magnes Museum. REFERENCES: *Encyclopaedia Judaica;* Benezit; *Jewish Art, An Illustrated History;* Pelz, Floran. *Jewish Artists Monographs.* Paris: Editions le Triangle, 1928.

P E T E R   K R A S N O W   Painter, sculptor, graphic artist. b. 1887 Ukraine, Russia. d. 1979. Immigrated U.S. 1908. EDUCATION/TRAINING: Art Institute of Chicago until 1916. ONE-ARTIST EXHIBITIONS: Whitney Studio Club, New York City, 1922; Los Angeles County Museum, 1922, 1927; Oakland Art Museum, California, 1928; Scripps College, Claremont, California, 1929, 1964; Stendahl Art Galleries, Los Angeles, 1930, 1940; California Palace of the Legion of Honor, San Francisco, 1931; Galerie Pierre, Paris, 1934; University of California, Los Angeles, 1935, 1940; Fine Arts Gallery of San Diego, California, 1939; Pasadena Art Institute, California, 1954; Los Angeles Municipal Art Gallery, 1975; Judah Magnes Museum, 1978; Hebrew Union College Skirball Museum, Los Angeles, 1978-79. GROUP EXHIBITIONS: California-Pacific International Exposition, San Diego, 1935; Museu de Arte Moderna, São Paulo, Brazil, III Bienal, 1955; Los Angeles Institute of Contemporary Art, 1974; San Francisco Museum of Modern Art, 1976; Rutgers University Art Gallery, New Brunswick, New Jersey, 1979; Oakland Museum, 1982; Hebrew Union College Skirball Museum, 1983. COLLECTIONS: Oakland Museum; Judah Magnes Museum; Hebrew Union College Skirball Museum. REFERENCES: *Peter Krasnow: A Retrospective Exhibition of Paintings, Sculpture, and Graphics.* Berkeley, California: Judah Magnes Museum, 1978; *100 Years of California Sculpture.* Oakland, California: Oakland Museum, 1982, p. 30; *Peter Krasnow: A Retrospective Exhibition.* Los Angeles: Los Angeles Municipal Art Gallery, 1975.

A B R A M   K R O L   Painter, graphic artist, book illustrator, sculptor. b. 1919 Poland. Immigrated Paris, 1939. EDUCATION/TRAINING: L'École des Beaux-Arts, Avignon; Caen University. AWARDS: Scholarship for travel by the French Government, 1950; Scholarship by the Fondation Fénéon, 1951; Daragnès Award, 1952; The Art Critics Prize, 1958. ONE-ARTIST EXHIBITIONS: Galerie Katia Granoff, Paris, 1946; S.D.S. Central-ens, Malmo, Sweden, 1949; Galerie Marcel Sautier, Paris, 1952; Librairie des Arts, Nancy, 1952; Galerie Van Lier, Amsterdam, 1953; Galerie Bignou, Paris, 1954; Galerie Aktuaryus, Strasbourg, 1955; S.D.S. Centralens, Malmo, 1955; Musee de São Paulo, Brazil, 1955; Galerie Marcel Sautier, Paris, 1956; Galerie Bignou, Paris, 1957; Galerie Aktuaryus, Strasbourg, 1958; A la Gravure, Paris, 1958; Galerie du Grand Chêne, Lausanne, 1958; Clark Memorial Library, University of California, 1958; Librairie des Arts, Nancy, 1959; Bien-nale de Venice, 1960; Paris Arts Gallery, San Francisco, 1961. BOOKS ILLUSTRATED BY: Gustave Flaubert, Andre Gide, Jean Cassou, Racine, Bruno Durocher, La Fontaine, F.

# B I O G R A P H I E S

G. Lorca, Franz Kafka, Paul Valéry and Oscar Wilde. COLLECTIONS: W. A. Clark Memorial Library, Los Angeles; Victoria and Albert Museum, London; British Museum, London; Boymans Museum, Rotterdam; Musée d'Art Moderne, Paris; Musée de Nice, France; Ein-Harod Museum, Israel; Tel-Aviv Museum, Israel; Museum of Modern Art, New York; Achenbach Foundation for Graphic Arts, San Francisco; Bibliothèque Nationale, Paris; Harvard University, Houghton Library; Congress Library, Washington D.C.; Bodleian Library, Oxford, England; Bibliothèque de l'Université, Amsterdam; Hebrew University Library, Jerusalem; Bibliothèque Royale, Brussels; Pinacothèque, Athens; Singer-Polignac Foundation, Paris; Judah Magnes Museum. REFERENCES: *Krol—Dix Années de Livres.* Paris: École Estienne, 1959; Benezit; *Encyclopaedia Judaica.* Volume 10, p. 662; *Krol.* San Francisco: Paris Art Gallery.

BEN KUTCHER Graphic artist, watercolorist, book illustrator, set designer. b. 1895 Russia. d. 1967. Immigrated United States 1902. Settled California 1927. PROFESSIONAL: Sold sketches made for Diaghilev's Ballet Russe to *Vogue, Town & Country, New York Tribune.* After World War I did advertising, stage production, theatrical work, designed bookplates, art director of Vine Street Theatre, Hollywood. BOOKS ILLUSTRATED: *Venus and Adonis* by Shakespeare, *Lalla Rookh* by Thomas Moore, Anderson's *Fairy Tales,* Oscar Wilde's *House of Pomegranates.* EXHIBITIONS: Retrospective, Judah Magnes Museum, 1970; Laguna Beach Museum of Art, *Drawings and Illustrations by Southern California Artists before 1950,* 1982. COLLECTIONS: Judah Magnes Museum. REFERENCES: Artist's file, Judah Magnes Museum; *Drawings and Illustrations by Southern California Artists before 1950.* Laguna Beach Museum of Art, 1982.

RACHEL LANDES Painter, printmaker. b. 1924 United States. Moved to Israel, 1968. EDUCATION/TRAINING: University of California, Berkeley (B.A., 1945); California College of Arts and Crafts, Oakland. EXHIBITIONS: Beaux Art Gallery, Oakland, 1964; Lucien Lebaudt Gallery, San Francisco; Artists Cooperative, San Francisco, 1967; In Israel: Beit Rothschild, Haifa, 1975; Gallery Armon, Old City, Jerusalem; Gallery 3, Haifa, 1981; Artists' House, Jerusalem, 1982; Riebenfeld Gallery, Old Jaffa, 1982. GROUP EXHIBITIONS: *S.F. Women Artists,* Museum of Modern Art, San Francisco, 1961; Oakland Art Museum, OAA, 1963-64; Beth Abraham Art Show, 1965; Illustrated Folksayings Graphics Show, Jerusalem Artists' House, 1978. COLLECTIONS: Judah Magnes Museum. REFERENCES: Artist's file, Judah Magnes Museum.

JACK LEVINE Painter, graphic artist. b. 1915 United States. EDUCATION/TRAINING: Studied with Denman W. Ross, Harold Zimmerman. MEMBER: National Institute of Arts and Letters, New York City; Academy of Arts and Sciences; Artists Equity. Federal A.P.: Easel painting. TEACHING: American Art School, New York City; Pennsylvania Academy of the Fine Arts, Philadelphia; Skowhegan School of Painting and Sculpture, Maine; Cleveland Museum of Art; Art Institute of Chicago; University of Illinois. AWARDS: Carnegie, 1946; Corcoran, 1959; Pennsylvania Academy of the Fine

# B  I  O  G  R  A  P  H  I  E  S

Arts, 1948; National Institute of Arts and Letters, 1946; Guggenheim Foundation Fellowship, 1946; Hon. DFA, Colby College; National Academy of Design, Benjamin Altman Prize, 1975. ONE-ARTIST EXHIBITIONS: Downtown Gallery, New York City, 1939, 1948, 1952; Boris Mirski Gallery, Boston, 1950; Alan Gallery, New York City, 1953, 1957, 1959, 1963, 1966; Art Institute of Chicago, 1955; Philadelphia Art Alliance, 1955; Colby College, 1956; Randolph-Macon Women's College, 1960; New Art Center, Detroit, 1962; B'nai B'rith Building, Washington D.C., 1965; Kovler Gallery, Chicago, 1966; Athena Gallery, New Haven, 1967; Graphics, Inc., New York City, 1967; George Washington University, 1967; Galeria Colibri, San Juan, 1968; De Cordoba and Dana Museum, Lincoln, Massachusetts, 1968; Galleria d'Arte il Gabbiano, Rome, 1968; Muggleton Art Gallery, Auburn, New York, 1968; Art Harris Art Gallery, Los Angeles, 1970; Kennedy Gallery, New York City, 1972, 1973, 1975, 1977; Rodman Hall Arts Center, St. Catherines, Ontario, 1978. RETROSPECTIVES: Long Beach Museum of Art, 1971. GROUP EXHIBITIONS: Museum of Modern Art, New York. *New Horizons in American Art,* 1936; Whitney Museum of American Art Annuals, 1937 to 1967; Musée de Jeu de Paume, Paris, *Three Centuries of American Art,* 1938; Carnegie, International Exhibition, 1938-55; Museum of Modern Art, New York, *Art in Our Time,* 1939; Pennsylvania Academy of the Fine Arts, Philadelphia, Annuals, 1940-1968; Museum of Modern Art, *Thirty-five under Thirty-Five,* circ., 1940; Institute of Modern Art, Boston, *Painting by 50 Oncoming Americans,* 1941; Metropolitan Museum of Art, New York, *Artists for Victory,* 1942; WAC, *92 Artists,* 1943; National Academy of Design, 1946; Tate Gallery, London, *American Painting from the Eighteenth Century to the Present Day,* 1946; Corcoran Biennials, 1947-1959; Institute of Contemporary Art, Boston, *American Painting in Our Century,* circ., 1949; University of Illinois, 1949-1967; Metropolitan Museum of Art, *American Painting Today,* 1950; University of Minnesota, *40 American Painters,* 1940-1950; São Paulo, Biennial, 1951; Butler Institute of Youngstown, Ohio, *The American Jew in Art,* 1955; Museum of Modern Art, New York, *Modern Art in the U.S.A.,* circ. internationally, 1955; XXVIII Venice, Biennial, 1956; Smithsonian, *Fulbright Painters,* circ., 1958; U.S. Dept. of State, *American Painting and Sculpture,* circ. internationally, 1959; Milwaukee Art Center, *ART: USA: NOW,* 1962; Washington, D.C., Gallery of American Art, *U.S. Government Art Projects: Some Distinguished Alumni,* 1963; Minneapolis Institute of Arts, *Four Centuries of American Art,* 1963; Metropolitan Museum of Art, *Three Centuries of American Paintings,* 1965; Corcoran Gallery of Art, Washington, D.C., *Two Hundred Fifty Years of American Art,* 1966; Cleveland Museum of Art, *Four Centuries of American Art,* 1966; Whitney Museum of American Art, *Art in the United States 1670-1966,* 1966; Whitney Museum of American Art, *The 1930s: Painting and Sculpture in America,* 1968; Joslyn Art Museum, Omaha, *The Thirties Decade: American Artists and Their European Contemporaries,* 1971; Pushkin Museum, Moscow, *Representations of America,* circ., 1977. COLLECTIONS: Phillips Academy, Addison Gallery of American Art, Massachusetts; Museum of Fine Arts, Boston; Brooklyn Museum; California Palace of the Legion of Honor; Art Institute of Chicago; Harvard University; State University of Iowa; University of Kansas; Metropolitan Museum of Art, New York; Museum of Modern Art, New York; University of Nebraska; University of Oklahoma; Pennsylvania Academy of the Fine Arts, Philadelphia; Phillips Gallery, Washington, D.C.; Portland Art Museum, Oregon; Utica Munson-Williams-Proctor Institute, Utica, New York; Whitney Museum of American Art; Wichita Art Museum; Walker Art Center, Minneapolis; Judah Magnes Museum. REFERENCES: Getlein, Frank. *Monograph.* New York: Harry Abrams, 1965; Michener, James A., and Jack Levine. *Facing East.* New York: Maecenas Press, Random House, 1970; Prescott, Kenneth W. *Jack Levine Retrospective Exhibition, Paintings, Drawings, Graphics.* New York: The Jewish Museum, 1979; Levine, Jack. Letter to Florence Helzel, March 1983; *Dictionary of Contemporary American Artists.*

# B I O G R A P H I E S

**EPHRAIM MOSHE LILIEN** Painter, printmaker, book illustrator. b. 1874
Austria. d. 1925. EDUCATION/TRAINING: Studied art in Cracow; Academy of Fine
Arts, Vienna. PROFESSIONAL: One of the founders of Berlin publishing house,
"Juedischer Verlag," served as illustrator, editor, manager and publicity agent. Collabo-
rated closely with Theodor Herzl; did Herzl portraits and decorations for the Golden Book
of Jewish National Fund. In 1905, with Boris Schatz and others, established Bezalel School
of Art, Jerusalem. TEACHING: Bezalel School of Art, 1906-07. ILLUSTRATED: *Juda;
Chants de Borries; Baron de Munchhausen; Chansons de Ghetto* by Morris Rosenfeld; *Chants
d'Annunzio.* EXHIBITIONS: Glitzenstein Museum, Safad, 1968; Hebrew Union College
Skirball Museum, 1976, 1981. COLLECTIONS: Judah Magnes Museum; Hebrew Union
College Skirball Museum, Los Angeles; Maurice Spertus Collection of Judaica, Chicago.
REFERENCES: *Encyclopaedia Judaica; Jewish Painters and Jewish Themes in Art.* Safad, Israel:
Glitzenstein Museum, 1968; *Jewish Art: An Illustrated History,* pp. 617-18; Levussove, M. S.
*The New Art of an Ancient People: The Work of Ephraim Moshe Lilien.* New York: B. W.
Huebsch, 1906; Brieger, L. *E. M. Lilien.* Berlin/Vienna: Benjamin Hartz, 1922; Benezit; *The
Hebrew Book.* Edited by Posner and Ta-Shema. New York: Leon Amiel Publishers, 1975.

**LOUIS MARCOUSSIS** Painter, printmaker, book illustrator. b. 1883 Poland. d.
1941. Immigrated Paris 1903. EDUCATION/TRAINING: Academy of Fine Arts,
Cracow. Studied in Paris, influenced by French culture. PROFESSIONAL: Contributed
drawings to "La Vie Parisienne," "L'Assiette au Beurre." ILLUSTRATED BOOKS BY:
Gerard de Nerval, Guillaume Apollinaire and Tristan Tzara. EXHIBITIONS: Salon
d'Automne, Paris, 1907; Salon d'Automne, Berlin, 1913; Salon des Indépendants, Berlin,
1920; Paris, 1926; Brussels, 1928; Paris, 1929; New York and Chicago, 1933. RETROSPEC-
TIVE: National Museum of Modern Art, Paris, 1964. COLLECTIONS: National Gallery,
Washington, D.C.; New Haven; Musée d'Art Moderne, Paris; Musée Municipale d'Art
Moderne de la Ville, Paris; Musée d'Art et d'Industrie, Saint Etienne; Saarland Museum,
Sarrebruck; Peggy Guggenheim, Venice; Judah Magnes Museum. REFERENCES: Lafran-
chis, Jean. *Marcoussis.* Paris: Les Editions du Temps, 1961. *Encyclopaedia Judaica,* p. 943;
Benezit.

**JOSEPH MARGULIES** Painter, etcher, portraitist. b. 1896 Austria. EDUCA-
TION/TRAINING: Cooper Union National Academy of Design; Art Students League,
New York, with Joseph Pennell; École des Beaux-Arts, Paris; and with Maynard Waltner,
Vienna. Member of Art Students League, New York. AWARDS: Louis E. Seley Purchase
Prize for oil paintings, Salmagundi Exhibition, 1959; 1962, 1963 won first prize for etching
at the same exhibition; Gold Medal, American Professional Artists League for etching,
Grand National Exhibition, 1965. COMMISSIONS: Portraits of President Eisenhower and
President Nixon for the cover of *Newsweek,* 1961; portrait of John F. Brosnan, regent and
chancellor, State University of New York, 1961; portrait of Senator Jacob K. Javits,
commissioned by Attorney General, New York State Capitol, Albany; portrait of Con-
gressman Emanuel Celler, commissioned by chairman Judiciary Staff, 1963; portrait of Dr.
Bela Schick, National Portrait Gallery, 1969; portrait of John Dewey for Dewey Center,

# B I O G R A P H I E S

Carbondale, Illinois. EXHIBITIONS: University of Maine, 1965; yearly exhibitions, Provincetown Art Association; Audubon Artists; Allied Artists American & American Watercolor Society. COLLECTIONS: National Portrait Gallery, Smithsonian Institution; Library of Congress & Judiciary, House of Representatives, Washington, D.C.; Metropolitan Museum of Art, New York; Cleveland Museum of Art; New York Public Library; Brooklyn Museum; Yale University; Iowa State Collection; Baltimore Museum of Art; Judah Magnes Museum. Portraits of noted jurists, philanthropists and government officials are exhibited in leading public buildings throughout the United States. REFERENCES: Benezit; *Who's Who in American Art.*

LUDWIG MEIDNER  Painter, graphic artist. b. 1884 Germany. d. 1966. EDUCATION/TRAINING: Breslau Academy, 1903-05; Academies Julian and Corman, 1906; joined the Novembergruppe, 1908. PROFESSIONAL: Founded "Die Pathetiker" with Jakob Steinhardt and Richard Janthur; wrote two books, taught in a Jewish school in Cologne. EXHIBITIONS: First exhibition Sturm Gallery, 1912. COLLECTIONS: Mills College Art Gallery, Oakland; Judah Magnes Museum; Hebrew Union College Skirball Museum, Los Angeles. REFERENCES: Whitford, Frank. *Drawings and Prints from the D. Thomas Collection.* University of Notre Dame, 1972; Benezit; Selz, Peter. *German Expressionist Painting.* Berkeley: University of California Press, 1974; *Jewish Art, An Illustrated History.*

JAKOB NUSSBAUM  Painter, graphic artist. b. 1873 Germany. d. 1936. Immigrated Palestine 1933. EDUCATION/TRAINING: Simon Hollosy's private art school, Munich, 1893-94. Student of Gabriel von Hackl, Academy, Munich, 1894-95. Member of Hollosy's artists' colony, Nagybanya. AWARDS: Silver medal, International Sports and Games Exhibition, Frankfurt, for painting, *Bicycle Riders,* 1910. EXHIBITIONS: Städelsches Kunstinstitut, Städelsches Galerie, Frankfurt am Main, West Germany, 1973; Judah Magnes Museum, 1982. COLLECTIONS: Municipal Gallery, Frankfurt; Hebrew University Hadassah Medical School, Jerusalem; Judah Magnes Museum. REFERENCES: *Journey's End in Galilee.* Berkeley: Magnes Museum, 1982. *Jakob Nussbaum Memorial Exhibition.* Frankfurt am Main, West Germany: Städelsches Kunstinstitut, 1973.

MORITZ DANIEL OPPENHEIM  Painter, draftsman. b. 1799 Germany. d. 1882. EDUCATION/TRAINING: Studied with Jean-Baptiste Regnault, Paris, who was a follower of Jacques Louis David's neoclassicism. In Rome was associated with the Nazarenes; Munich Academy where he learned lithography. EXHIBITIONS: L'Académie Royale, Berlin, 1926; Jewish Museum, New York, 1981. COLLECTIONS: Jewish Museum, New York; Jewish Museum, Berlin; Bremen Museum; Cologne Museum; Copenhagen Thorwalds Museum; Dusseldorf Municipal Museum; Frankfurt (Stadel); Goethe Museum, Hamburg; Hanau Académie de Dessin; Leipzig; Judah Magnes Museum. REFERENCES: Kleeblatt, Norman L. *The Paintings of Moritz Oppenheim, Jewish Life in 19th C. Germany.* New York: The Jewish Museum, 1982; Benezit.

# B  I  O  G  R  A  P  H  I  E  S

A B E L   P A N N   Painter, cartoonist, graphic artist. b. 1883 Latvia. d. 1963. Immigrated Palestine 1913. EDUCATION/TRAINING: Studied in Odessa, Vilna and Paris under Bouguereau and Toulouse-Lautrec. AWARDS: Prix National by French Académie des Beaux Arts. EXHIBITIONS: Oakland Jewish Community Center, 1962; Hebrew Union College Skirball Museum, 1981, 1983. COLLECTIONS: Hebrew Union College Skirball Museum; Yad Vashem, Israel; Jerusalem Museum; Judah Magnes Museum; Maurice Spertus Collection of Judaica, Chicago. REFERENCES: *Encyclopaedia Judaica,* p. 607; artist's file, Judah Magnes Museum; Benezit.

H A R O L D   P E R S I C O   P A R I S   Sculptor, printmaker, author. b. 1925 United States. d. 1979. EDUCATION/TRAINING: Atelier 17, New York City, 1949; Creative Lithographic Workshop, New York City, 1951-52; Akademie der Bildenden Kunste, Munich, Germany, 1955-56. TEACHING: University of California, Berkeley, 1960-79. ONE-ARTIST EXHIBITIONS: Paul Kantor Gallery, Los Angeles, 1961, 1962; Bolles Gallery, San Francisco, 1962; Hansen Galleries, San Francisco, 1965, 1967, 1969; Smith Andersen Gallery, Palo Alto, 1972, 1973, 1975, 1976, 1977; University Art Museum, Berkeley, 1972; Denver Art Museum, 1973; Quay Gallery, San Francisco, 1974; Polly Friedlander Gallery, Seattle, 1975; Stephen Wirtz Gallery, San Francisco, 1978; Diane Brown Gallery, Washington, D.C., 1979. GROUP EXHIBITIONS: Museum of Modern Art, New York, 1948, 1953, 1959; Pennsylvania Academy of the Fine Arts, Philadelphia, 1949, 1950, 1952, 1954; Philadelphia Museum of Art, 1953, 1954, 1956, 1959; Metropolitan Museum of Art, New York, 1953; San Francisco Museum of Art, 1953, 1961, 1962, 1964, 1965, 1969, 1970; Whitney Museum of American Art, New York, 1956, 1964, 1968, 1969; Museum of Contemporary Crafts, New York, 1963; University Art Museum, Berkeley, 1967; Los Angeles County Museum of Art, 1967; Institute of Contemporary Art, University of Pennsylvania, 1969; Jewish Museum, New York, 1969; Fondation Maeght, St. Paul, France, 1970; Musée de la Ville de Paris, 1970; Whitney Museum of American Art, 1969; San Francisco Museum of Modern Art, 1976. COLLECTIONS: University of California Art Museum, Berkeley; Art Institute of Chicago; University of Delaware; Goddard College, La Jolla, California; Library of Congress; The Museum of Modern Art, New York; New York Public Library; University of North Dakota; The Oakland Museum; San Francisco Museum of Modern Art; Philadelphia Museum of Art; Judah Magnes Museum. REFERENCES: Selz, Peter. *Harold Paris: The California Years.* Berkeley, California: University Art Museum, 1972; *100 Years of California Sculpture.* Oakland, California: The Oakland Museum, 1982; Benezit; *Who's Who in American Art; Dictionary of Contemporary American Artists,* 1977.

B E R N A R D   P I C A R T   Painter, graphic artist. b. 1673 Paris. d. 1733. Settled in Amsterdam 1710. EDUCATION/TRAINING: Student of his father, Etienne; taught by Sebastin le Clerc. TEACHING: Taught extensively in Amsterdam. PROFESSIONAL: Illustrated the section devoted to Jews in the first volume of an 11-volume work, *Cérémonies et Coutumes Religieuses de tous les Peuples du Monde,* 1723; Wrote *Figures de Modes et Théâtrales,* 1696. COLLECTIONS: Stedelijk Museum, Amsterdam; Judah Magnes Museum; Hebrew Union College Skirball Museum; Maurice Spertus Collection of Judaica, Chicago. REFERENCES: Rubens, Alfred. *A Jewish Iconography.* London: The Jewish Museum, 1954; Rubens, Alfred. *A Jewish Iconography.* London: Nonpareil, 1981; Benezit; *Encyclopaedia Judaica,* p. 498.

# B  I  O  G  R  A  P  H  I  E  S

JACOB PINS  Printmaker. b. 1917 Germany. Immigrated Israel 1936. EDUCA-
TION/TRAINING: Studied with Jakob Steinhardt and the Jerusalem School of artists from
1941-45. TEACHING: Lecturer, Bezalel Academy of Arts and Design, Jerusalem, from
1956 to present; teacher of woodcuts. PROFESSIONAL: Cofounder of Jerusalem Artists
Group and Jerusalem Artists House, 1949. AWARDS: The Ohara Museum's prize at the 1st
International Biennale of prints in Tokyo, 1957; Jerusalem prize, 1962; nominated honorary
member of the Accademia delli Arti del Disegno, Florence, 1963. ONE-ARTIST EXHIBI-
TIONS: Tel Aviv, 1945, 1946, 1949, 1952, 1956; Jerusalem, 1953, 1956, 1960, 1965, 1967;
Haifa, 1954, 1958; Public Library, Boston, 1953; U.S. National Gallery, Washington, D.C.,
1954; London, 1955, 1964; New York, 1959; Zurich, 1960; Bogota, 1962; Melbourne, 1963;
Sydney, 1964; San Jose, Costa Rica, 1968; Judah Magnes Museum, 1974. GROUP EXHIBI-
TIONS: Black and White Biennale, Lugano, Switzerland, 1955; Annual Exhibition of the
Society of Woodengravers, London, 1957; Biennale of Graphic Art, Ljubljana, Yugoslavia,
1959-61; Xylon International Woodcut Exhibition, Schaffhausen, Berlin; Gelsenkirchen,
Ljubljana, 1959-62; XXX Biennale, Venice, 1960; Israel Graphic Exhibition, Tokyo, 1962;
30th Exhibition of the Japanese Print Association, Tokyo, 1962; Israel Graphic, Ljubljana,
Yugoslavia, 1962; Israel Graphic, Warsaw, Poland and Moscow, Russia, 1964-65; Israel
Graphic, Melbourne, Sydney, Adelaide, Australia, 1965; 1st International Exhibition of
Original Drawings, Rijeka, Yugoslavia, 1968; 1st Biennale, Florence, 1968; Xylon 1st
International Triennale of Contemporary Woodcuts, Capri, Italy, 1969; 2nd Biennale,
Florence, 1970; 3rd Biennale, Florence, 1972. COLLECTIONS: Metropolitan Museum of
Art, New York; Museum of Modern Art, New York; Harvard University's Fogg Museum;
Boston Museum of Fine Arts; Art Institute of Chicago; National Gallery, Washington,
D.C.; National Museum, Warsaw; Pushkin Museum, Moscow; Ohara Museum, Tokyo;
Stedelijk Museum, Amsterdam; Judah Magnes Museum. REFERENCES: Nesvisky,
Matthew. "The Jerusalem of Jacob Pins," *Israel Magazine.* Vol. 5, No. 9, September 1973;
*Master Woodcuts by Jacob Pins.* Berkeley: Judah Magnes Museum, 1974.

MAX POLLAK  Painter, etcher. b. 1886 Czechoslovakia. d. 1970. Immigrated
United States 1927. EDUCATION/TRAINING: Studied painting and etching at the
Vienna Academy of Art under William Unger and Ferdinand Schmutzer, 1904-12. Also
studied in Paris and Holland, 1912. PROFESSIONAL: Appointed as painter by the Austrian
Army to paint propaganda pictures, 1915; illustrated Theodore Dreiser's book, *My City,*
1929; honorary life member, California Society of Etchers. AWARDS: Blumenthal prize,
1911; Grand Prix de Rome for etching, 1912. ONE-ARTIST EXHIBITIONS: Gump's
Gallery, San Francisco, 1930; Gillespies' Gallery, Pittsburgh, 1930; Ferargil Galleries, New
York, 1936; Closson Galleries, Cincinnati, 1936; Junior League Building, Houston, 1938;
Gump's Gallery, San Francisco, 1939; California Palace of the Legion of Honor, San
Francisco, 1940; University of California Art Gallery, Berkeley, 1949. EXHIBITIONS:
Bernays Gallery, New York, 1927; Ferargil Galleries, New York, 1928; permanent gallery
in V. C. Morris store, Maiden Lane, San Francisco, 1944-57; memorial exhibition, Achen-
bach Foundation for Graphic Arts, Fine Arts Museums of San Francisco, 1971; retrospective
exhibition, Triton Museum of Art, Santa Clara, California, 1973; Oakland Museum, 1982;
Judah Magnes Museum, 1982. COLLECTIONS: Metropolitan Museum of Art, New York;
Mills College, Oakland; San Francisco Museum of Modern Art; Smithsonian Institution;
Oakland Museum; Galerie Modern, Prague; Judah Magnes Museum. REFERENCES:
Heyman, Therese. *Three Etchers in California.* Oakland, California: The Oakland Museum,
1982; Conversation with Mrs. Friedl Pollak, February 4, 1982; Benezit; *Max Pollak: In
Retrospect 1886-1970.* Santa Clara: Triton Museum of Art, 1973.

# B I O G R A P H I E S

**S A U L  R A B I N O**  Painter, graphic artist, muralist. b. 1892 Russia. Immigrated United States 1922. EDUCATION/TRAINING: Imperial Art School, Russia; École des Arts Decoratifs, 1913. EXHIBITIONS: Los Angeles Museum of History; Laguna Beach Art Society; World's Fair, New York, 1939. COLLECTIONS: Los Angeles Public Library; Judah Magnes Museum. REFERENCES: Artist's file, Judah Magnes Museum.

**J O S E P H  R A P H A E L**  Painter, graphic artist. b. 1869 United States. d. 1950. EDUCATION/TRAINING: California School of Fine Arts. Studied painting with Arthur Mathews, modeling with Douglas Tilden; Académie Julian and École des Beaux Arts, Paris, studied under Jean Paul Laurens, 1903. AWARDS: Honorable Mention, Salon de Paris, 1915; Silver Medal, Panama-Pacific Exposition, San Francisco, 1915; 1st Purchase Prize, San Francisco Art Association; Gold Medal, San Francisco Art Association, 1918. EXHIBITIONS: Judah Magnes Museum, 1975; Stanford University Museum of Art, Palo Alto, 1980. COLLECTIONS: Oakland Museum; San Francisco Art Association; Fine Arts Museums of San Francisco; Judah Magnes Museum. REFERENCES: *The Creative Frontier.* Berkeley: Judah Magnes Museum, 1975; Benezit; *Who's Who in American Art 1938-1939.*

**A B R A H A M  R A T T N E R**  Painter, printmaker, tapestry designer, teacher. b. 1893 United States. d. 1978. EDUCATION/TRAINING: George Washington University; Corcoran School of Art; Pennsylvania Academy of the Fine Arts, Philadelphia, 1916-17; Académie Julian, Paris; Académie des Beaux-Arts, Paris; Académie Ranson, Paris; Académie de la Grande Chaumière, 1920. TEACHING: New School for Social Research, 1947-55; Yale University, 1949; Brooklyn Museum School, 1950-51; American Academy, Rome, 1951; University of Illinois, 1952-54; Art Students League, 1954; Pennsylvania Academy of the Fine Arts, 1954; Sag Harbor Summer Art Center, 1956; Michigan State University, 1956-58. COMMISSIONS: St. Francis Monastery, Chicago, 1956; Fairmount Temple, Cleveland, 1957; Loop Synagogue, Chicago, 1958; Duluth Synagogue, Duluth, Minnesota; De Waters Art Center, Flint, Michigan, 1958; U.S. Navy Department, Washington, D.C. AWARDS: Pennsylvania Academy of the Fine Arts, Cresson Fellowship, 1919; Pennsylvania Academy of the Fine Arts, Joseph E. Temple Gold Medal, 1945; Pepsi-Cola, Second Prize, 1946; La Tausca Competition, First Prize, 1947; Carnegie, Honorable Mention, 1949; University of Illinois, Purchase Prize, 1950; Corcoran First Prize, 1953; National Institute of Arts and Letters, New York, 1958. ONE-ARTIST EXHIBITIONS: Gallerie Bonjean, Paris, 1935; Julian Levy Galleries, New York, 1936-41; Courvoisier Gallery, San Francisco, 1940; Arts Club of Chicago, 1940; P. Rosenberg and Co., 1943, 1944, 1946, 1948, 1950, 1952, 1956; Stendahl Gallery, Los Angeles, 1943; Santa Barbara Museum of Art, 1943; Philadelphia Art Alliance, 1945; Arts and Crafts Club, New Orleans, 1952; Art Institute of Chicago, 1955; Renaissance Society, 1957; Downtown Gallery, 1957, 1958, 1960, 1966; Corcoran Gallery of Art, Washington, D.C., 1958; North Shore Congregation Israel, Chicago, 1958; The Whitney Museum of American Art; Galerie Internationale, New York City, 1961; The Contemporaries, New York City, 1967; Kennedy Gallery, New York, 1969, 1970, 1972, 1974, 1975, 1978, 1979; New School for Social Research, New York, 1970; National Collection of Fine Arts, 1976. RETROSPEC- TIVES: Baltimore Museum of Art, 1946; Vassar College, 1948; University of Illnois, 1952; American Federation of Arts, New York, circ., 1960. GROUP EXHIBITIONS: Pennsyl- vania Academy of the Fine Arts; Corcoran; Art Institute of Chicago; University of Illinois; Carnegie Institute of Technology, Pittsburg, Penn.; Metropolitan Museum of Art, New

# B I O G R A P H I E S

York; Whitney Museum of American Art, New York; Albright-Knox Art Gallery, Buffalo; Baltimore Museum of Art; Detroit Institute of Arts, Michigan; Des Moines Art Center, Iowa; New School for Social Research, New York City. COLLECTIONS: Arizona State College; Ball State University; Albright-Knox Art Gallery, Buffalo, New York; CIT Corporation; Art Institute of Chicago; Cornell University; Dartmouth College; Des Moines; Detroit Institute of Arts, Michigan; Fort Worth Art Center, Texas; Wadsworth Atheneum, Hartford, Connecticut; University of Illinois; Jewish Museum, New York; Johnson College; Metropolitan Museum of Art, New York; Manufacturers Hanover Trust Co.; Marquette University; Michigan State University; Musée de Jeu de Paume, Paris; University of Nebraska; Newark Museum; New School for Social Research; University of Oklahoma; Pennsylvania Academy for Fine Arts, Philadelphia; Philadelphia Museum of Art, Pennsylvania; Phillips Gallery, Washington, D.C.; City Art Museum of St. Louis, Missouri; Santa Barbara Museum of Art, California; Vassar College; Whitney Museum of American Art, New York; Walker Art Center, Minneapolis; Washington University; Williams College; Yale University; Butler Institute of American Art, Youngstown, Ohio; Judah Magnes Museum. REFERENCES: *Encyclopaedia Judaica*, p. 607; *New York Times* obituary by John Russell, February 15, 1978; Benezit; *Dictionary of Contemporary American Artists.*

LIONEL S. REISS Painter, printmaker, illustrator, author. b. 1894 Austria. Immigrated United States 1899. EDUCATION/TRAINING: Studied New York, Paris, Berlin. MEMBER: American Watercolor Society; Audubon Artists; Poetry Society, America. AWARDS: 1st prize, New York, 1940; 1st prize, Museum of Modern Art, 1942; Association of American Artists, 1943. PROFESSIONAL: Published *My Models were Jews,* 1938; *New Lights, Old Shadows,* 1954; *A World at Twilight,* 1971. Teacher and lecturer. Illustrator for advertising agencies. Art director, Goldwyn Pictures Corp., 1914-19. EXHIBITIONS: Carnegie Institute of Technology, Pittsburg; Art Institute of Chicago; Brooklyn Museum; Pennsylvania Academy of the Fine Arts, Philadelphia; National Academy of Design; Baltimore Museum; Whitney Museum of American Art; Museum of Modern Art, New York. ONE-ARTIST EXHIBITIONS: Midtown Gallery, 1939; Association of American Art Galleries, 1944. COLLECTIONS: Harvard University Library; Jewish Museum, New York; New York Historical Museum; Brandeis University; Skirball Museum; Jewish Theological Seminary; Tel Aviv Museum; Israel Museum, Jerusalem; Columbia University; Judah Magnes Museum. REFERENCES: *Encyclopaedia Judaica,* p. 609; Reiss, Lionel S. *My Models Were Jews.* New York: The Garden Press, 1938; Reiss, Lionel S. *New Lights, Old Shadows.* New York: The Reconstructionist Press, 1954; *100 Contemporary American Jewish Painters and Sculptors.* New York:YKUF Art Section, 1947.

ROBERT I. RUSSIN Sculptor, draftsman. b. 1914 United States. EDUCATION/TRAINING: City College of New York, B.S., 1933, M.A., 1935; Graduate study under scholarship, Beaux Arts Institute of Design. TEACHING: Cooper Union Art Institute; professor of art, University of Wyoming, 1947; teaching fellow, City College of New York. COMMISSIONS: Lincoln Monument on the summit of Lincoln Highway; bust of Lincoln in the Lincoln Museum, Washington D.C.; fountain for City of Hope, Duarte, California; Benjamin Franklin monument on University of Michigan campus; stone statue of beaver for City College of New York campus. GROUP SHOWS: Metropolitan Museum

# B  I  O  G  R  A  P  H  I  E  S

of Art; Whitney Museum of American Art; Art Institute of Chicago; Newark Art Museum; Kansas City Art Museum; Joslyn Art Museum, Omaha; Pennsylvania Academy of the Fine Arts, Philadelphia. EXHIBITIONS: Wellons Gallery, New York, 1955; Main Street Gallery, Chicago, 1958; Western AIA Convention, Jackson, Wyoming, 1958; Heritage Gallery, Los Angeles, 1964, 1966; University of Wyoming Art Gallery, 1966; Denver Art Gallery, 1962; Tuscon Art Center Museum, 1966; Colorado Springs Fine Arts Center, 1967; Judah Magnes Museum, 1971. COLLECTIONS: Judah Magnes Museum. REFERENCES: *Who's Who in American Art;* artist's file, Judah Magnes Museum.

**I S S A C H A R  R Y B A C K**  Painter, draftsman, theatrical set and costume designer, ceramicist. b. 1897 Russia. d. 1935. Immigrated Paris 1926. EDUCATION/TRAINING: Studied Kiev Academy. PROFESSIONAL: Appointed drawing teacher by the Central Committee of the Jewish Cultural League, 1917. Designed sets and costumes for two Purim plays for the Ukrainian Jewish State Theatre, 1924-1926. ILLUSTRATED: *On the Jewish Fields of the Ukraine.* Paris: A. Simon & Cie, 1926; portfolio of lithographs depicting scenes of Jewish life in the shtetl; watercolors on the theme of pogroms. EXHIBITIONS: Wildenstein Galleries, Paris, 1935; Vienna; New York; Ryback House, Ramat Yosef, Israel, opened 1962. COLLECTIONS: Judah Magnes Museum. REFERENCES: *Jewish Art, An Illustrated History;* Benezit; *Issachar Ryback 1897-1935 His Life and Works.* A. Cherikover, editor. Paris: Memorial Committee in Memory of Issachar Ryback, 1937.

**B E N  S H A H N**  Painter, graphic artist, cartoonist. b. 1898 Lithuania. d. 1969. Immigrated United States 1906. EDUCATION/TRAINING: New York University; City College of New York, 1919-22; National Institute of Design, 1922; Art Students League. PROFESSIONAL/COMMISSIONS: Fresco for Community Building, Roosevelt, New Jersey, 1938-39; murals for Bronx Central Annex Post Office, New York, 1938; murals for Jamaica, Long Island, post office, 1939; murals, Social Security Building, 1940; designed posters, Office of War Information, 1942; commercial commissions for Container Corporation of America, Columbia Broadcasting System, Columbia Records, *Fortune, Time, Charm, Seventeen, Esquire, Harper's, Scientific American,* Vintage Books and others, 1943-63; chief artist, Political Action Committee, Congress of Industrial Organization, 1944-46; posters and campaign material for the Henry Wallace "Third Party" movement, 1948; designed sets for Jerome Robbins' ballet, "New York Export—Opus Jazz," 1958; mosaic for Congregation Oheb Shalom, Nashville, 1959; sets for e.e. cummings' play, "Images," and for Jerome Robbins' ballet, "Events," 1961; posters for Lincoln Center for the Performing Arts, New York, 1962. HONORS/AWARDS: Pennsylvania Academy of the Fine Arts; Pennell Memorial Medal, 1939, 1953; Alice McFadden Eyre Medal, 1952; Joseph E. Temple Gold Medal, 1956; *Look* magazine poll of "Ten Best Painters," 1948; II São Paulo Biennial, 1953; XXVII Venice Biennial, 1954; Harvard University, Medal, 1956; American

# B I O G R A P H I E S

Institute of Graphic Art, Medal, 1958; North Shore, Long Island, New York, Art Festival Annual Award, 1959. ONE-ARTIST EXHIBITIONS: Downtown Gallery, 1930, 1932, 1933, 1944, 1949, 1951, 1952, 1955, 1957, 1959, 1961; Julien Levy Galleries, New York, 1940; Museum of Modern Art, New York, 1947; Arts Council of Great Britain, circ., 1947; Albright Art School, 1950; Perls Galleries, 1950; Arts Club of Chicago, 1951; Santa Barbara Museum of Art, circ., 1952, also 1967; Houston Museum of Fine Arts, 1954; Detroit Institute of Arts (three-man), 1954; Art Institute of Chicago, 1954; XXVII Venice Biennial, 1954; Southern Illinois University, 1954; American Institute of Graphic Art, 1957; St. Mary's College, Indiana, 1958; Bucknell University, 1958; Katonah Art Gallery, New York, 1959; Leicester Gallery, London, 1959, 1964; University of Louisville, 1960; University of Utah, 1960; Library of New Haven, Connecticut, Jewish Community Center, 1961; Institute of Modern Art, Boston, Documentary, 1957; Stedelijk Museum, Amsterdam, 1961; Galeria Nazionale d'Arte Moderno, Rome, 1962; Museum of Modern Art, New York, *Ben Shahn,* circ., Europe, 1962; Randolph-Macon Woman's College, 1966; Philadelphia Museum of Art, 1967; Orlando, 1968; Kennedy Gallery, New York, 1968-69, 1970, 1971, 1973; Nantenshi Gallery, Tokyo, 1970; Syracuse University, 1977; Nardin Gallery, New York, 1979. GROUP EXHIBITIONS: Corcoran Gallery of Art, Washington, D.C.; Carnegie Institute of Technology, Pittsburg; Art Institute of Chicago; Whitney Museum of American Art, New York; University of Nebraska; Brooklyn Museum; Museum of Modern Art, New York; Albright-Knox Art Gallery, Buffalo. RETROSPECTIVES: Museum of Modern Art, New York, 1947; Institute of Contemporary Art, Boston, 1948; Osaka Municipal, 1970; National Museum of Western Art, Tokyo, 1970; Jewish Museum, New York, 1976; Fort Worth, 1977. COLLECTIONS: Abbott Laboratories; Phillips Academy, Addison Gallery of American Art, Massachusetts; Arizona State College; University of Arizona; Auburn University; Baltimore Museum of Art; Brandeis University; Brooklyn Museum; Albright-Knox Art Gallery, Buffalo; California Palace of the Legion of Honor; Carnegie Institute of Technology, Pittsburg; Art Institute of Chicago; Container Corporation of America; Cranbrook Academy of Art, Bloomfield Hills, Michigan; Dartmouth College; Des Moines Art Center; Detroit Institute of Arts; Fort Wayne Art Museum; University of Georgia; Grand Rapids Art Gallery; Wadsworth Atheneum, Hartford; Harvard University; University of Illinois; Indiana University; Inland Steel Company; Jewish Museum, New York; Metropolitan Museum of Art, New York; Museum of Modern Art, New York; Mary Washington College; University of Michigan; Museum of the City of New York; University of Nebraska; Newark Museum; University of Oklahoma; Joselyn Art Museum, Omaha; Pennsylvania Academy of Fine Arts; Phillips Gallery, Washington, D.C.; Sara Roby Foundation; City Art Museum of St. Louis; Santa Barbara Museum of Art; Smith College; Springfield Art Museum, Missouri; Syracuse University; Terry Art Institute; Virginia Museum of Fine Arts, Richmond; Whitney Museum of American Art, New York; Walker Art Center, Minneapolis; Wellesley College; Wesleyan University; Wichita Art Museum; Butler Institute of American Art, Youngstown, Ohio. REFERENCES: Prescott, Kenneth W. *The Complete Graphic Work of Ben Shahn.* New York: The New York Times Book Co., 1973; *The Dictionary of Contemporary American Artists.*

# B I O G R A P H I E S

R A P H A E L   S O Y E R   Painter, printmaker. b. 1899 Russia. Immigrated United States 1912. EDUCATION/TRAINING: Cooper Union; National Academy of Design, 1919-21; Art Students League with Guy DuBois. TEACHING: Art Students League; American Art School, New York; New School for Social Research; National Academy of Design, 1965-67. MEMBER: National Institute of Arts and Letters, New York City; National Academy of Design, New York City; Federal A.P.: Easel Painting. COMMISSIONS: U.S. Post Office, Kingsessing. AWARD/HONORS: Carnegie, Honorable Mention (3); Art Institute of Chicago, M. V. Kohnstamm Prize, 1932; Art Institute of Chicago, Norman Wait Harris Gold Medal, 1932; Pennsylvania Academy of the Fine Arts, Carol H. Beck Gold Medal, 1934; Art Institute of Chicago, Norman Wait Harris Bronze Medal, 1940; Pennsylvania Academy of the Fine Arts, Joseph E. Temple Gold Medal, 1943; Pennsylvania Academy of the Fine Arts, Walter Lippincott Prize, 1946; Corcoran, William A. Black Prize and Corcoran Gold Medal, 1951; *ART:USA:59*, New York, $1,000 prize, 1959. ONE-ARTIST EXHIBITIONS: Daniel Gallery, New York, 1929; L'Elan Gallery, New York, 1932; Curt Valentine Gallery, New York, 1933, 1934, 1935, 1957, 1958; Frank K. M. Rehn Gallery, New York, 1939; Treasury Section, Fine Arts Division, 1939; A.A.A. Gallery, New York, 1940, 1941, 1948, 1953, 1955; Weyhe Gallery, 1944; Philadelphia Art Alliance, 1949; ACA Gallery, 1960; Alfredo Valente Gallery, New York, 1961; Bernard Crystal Gallery, New York, 1962; Forum Gallery, 1964, 1966, 1967, 1972, 1977; Margo Feiden Galleries, New York, 1972; Galerie Albert Loeb, Paris, 1980. GROUP EXHIBITIONS: Salons of America, New York, 1926; Whitney Museum of American Art Annuals, 1932-; Pennsylvania Academy of the Fine Arts, 1934, 1943, 1946; Corcoran Gallery of Art, Washington, D.C., 1937, 1951; Virginia Museum of Fine Arts, Richmond, 1938; Art Institute of Chicago, 1940; Brooklyn Museum, 1941; Carnegie Institute of Technology, Pittsburg, 1944; Phillips Gallery, Washington, D.C., 1944; Dallas Museum of Fine Arts, 1945; California Palace of the Legion of Honor, 1945; Museum of Modern Art, New York, 1946; National Academy of Design, 1951, 1952; American Federation of Arts, New York City, 1967; National Academy of Design, *American Portrait Drawings*, 1980; New Jersey State Museum, Trenton, *American Art of the 1930's*, 1979; Akademie der Kunst, Berlin, *American Art: 1920-1940*, 1980. RETROSPECTIVES: Whitney Museum of American Art, New York, circ. 1967; Hirshhorn Museum, Washington, D.C., *Raphael Soyer Sixty-five Years of Printmaking*, 1982. COLLECTIONS: Phillips Academy, Addison Gallery of American Art, Massachusetts; University of Arizona; Museum of Fine Arts, Boston; Brooklyn Museum; Albright-Knox Art Gallery, Buffalo; Columbus Gallery of Fine Arts, Ohio; Corcoran Gallery of Art, Washington, D.C.; Detroit Institute of Arts; Wadsworth Atheneum, Hartford; Metropolitan Museum of Art, New York; Museum of Modern Art, New York; Montclair Art Museum, Montclair, New Jersey; University of Nebraska; Newark Museum; Nasjonalgalleriet, Oslo, Norway; Phillips Gallery, Washington, D.C.; Walter P. Chrysler Museum of Art, Norfolk, Virginia; Whitney Museum of American Art, New York; Judah Magnes Museum. REFERENCES: Cole, Sylvan, Jr. *Raphael Soyer, Fifty Years of Printmaking, 1917-1967*. New York: Da Capo Press, 1967; Gettings, Frank. *Raphael Soyer, Sixty-five Years of Printmaking*. Washington, D.C.: Smithsonian Institution Press, 1982; *Dictionary of Contemporary American Artists*.

# B I O G R A P H I E S

W A L T E R  S P I T Z E R  Painter, graphic artist, sculptor, book illustrator. b. 1927 Poland. Immigrated France. EDUCATION/TRAINING: École Nationale des Beaux-Arts de Paris, entered 1945. AWARDS: Prix du Salon de Montreuil-sous-Bois, 1953; Grand Prix des Jeunes Peintres à la Nationale des Beaux-Arts, Paris, 1957; Hors concours pour le Prix Drouant, Paris, 1957; Prix du Salon d'Asnières, 1958. ILLUSTRATED BOOKS BY: André Malraux, Joseph Kessel, Henry de Montherlant, J. P. Sartre and Jean Dutour. EXHIBITIONS: Salon d'Automne, Paris, 1952; Salon de Montreuil-sous-Bois, 1953; Salon de la Jeune Peinture, 1954-1965; Galerie Breteau; Salon d'Automne, 1956; National des Beaux-Arts; Musée d'Art Juif; Galerie Drouant; Salon des Indépendants; Salon de la Jeune Gravure Contemporaine (Musée d'Art Moderne, Paris); Galerie Monique de Groote, Paris and Brussels, 1957; Salon des Artistes Indépendants; Palais des Beaux-Arts de Liège, Belgium; Musée d'Art Moderne, Mexico; Salon d'Asnières; L'École de Paris, Frankfurt; Galerie le Soleil dans la Tête, Paris 1958; Salon des Peintres Temoins de leur Temps, Paris; Galliera "L'Age Mécanique," Paris; Galerie de Montmorency, Paris, 1959; L'Espagne en Artois, Arras, 1960; Chez Marcel Sautier; Musée d'Art Juif de Paris; Musée d'Art Moderne, Paris, 1961; Studio Maywald, Paris, 1962; Galerie Romanet, Paris, 1963; Comparaisons, 1964; Galerie Transposition 92, Paris; Jeunes Peintres à Saint-Denis; Musée de la Guerre, 1965; Scottish National Gallery of Modern Art; Galerie Drouant, 1966; Salon d'Art Contemporain, Villejuif; Galerie Agora, Paris; Scottish National Gallery of Modern Art, London, 1967; Estampes d'Artistes Contemporains au Moulin de Vauboyen, 1968; Exposition Internationale Du Figuratif, Tokyo, 1969; Litho Gallery, San Mateo, California; Groupements Culturels Juifs, Paris, 1970; Petit Palais, Geneva, 1971; Rolly-Michaux, Boston, 1972; Bibliothèque Nationale; L'Estampe Contemporaine, Paris, 1973; Millioud Gallery, Houston, 1974; Galerie Vendôme, Paris, 1975; Galerie d'Art Matignon, 1976; Galerie Vendôme, 1977; Galerie Aleph, Paris; Musee Idemitsu, Tokyo, 1978; Galerie Vendôme, 1979; Centre Rachi, Paris; Musée de l'Ordre de la Libération, Paris; Ramapo College, New Jersey, 1980; Salle du Doyenne du Syndicat d'Initiative de Saint-Emilion; Salle de la Renaissance du Vieux Bordeaux, 1981; Galerie du Perron, Geneva; Foire Internationale d'Art, New York; Musée de l'Homme, Paris, 1982. COLLECTIONS: Judah Magnes Museum; Hebrew Union College Skirball Museum. REFERENCES: *W. Spitzer.* Paris: Artspectives, 1982; Benezit.

N I K O S  S T A V R O U L A K I S  Painter, graphic artist, watercolorist. b. 1932 Greece. EDUCATION/TRAINING: Educated England, United States, Israel. Studied eastern history and humanities until returned to live in Greece, 1957. PROFESSIONAL: Director, Jewish Museum, Athens, Greece. BOOKS ILLUSTRATED: *The Book of Jeremiah,* Jewish Publication Society; *The Song of Songs,* Anvil Press; *Proverbs and People,* Judah Magnes Museum. EXHIBITIONS: First one-person show 1963, New Forms Gallery, Athens; Oxford, England; London; New York; Israel; Australia; Judah Magnes Museum, 1969; British Council, Athens, 1982; Has had 15 one-artist exhibitions, 20 group exhibitions. COLLECTIONS: Museum of Modern Art, New York; Christ Church College, University of Oxford; Judah Magnes Museum; Hebrew University, Jerusalem; Museum of Contemporary Greek Art, Rhodes. REFERENCES: *Woodcuts by Stavroulakis.* Berkeley: Judah Magnes Museum, 1969; Cross, Miriam Duncan. "Two Artists Brighten Berkeley Scene." *Oakland Tribune,* 1969.

# B I O G R A P H I E S

JAKOB STEINHARDT Painter, graphic artist. b. 1887 Germany. d. 1968. Moved to Berlin 1906. Immigrated Palestine 1933. EDUCATION/TRAINING: Studied with painter Lovis Corinth and engraver Hermann Struck, Berlin, 1906; with Henri Laurens, Theophile Steinlen and Henri Matisse, Paris, 1909. TEACHING/PROFESSIONAL: With Ludwig Meidner and Richard Janthur, founded expressionist group "Die Pathetiker," 1912; Headed graphic department, Bezalel Academy of Arts and Design, 1949; Director, Bezalel, 1953-57. AWARDS: International prize in graphic art, São Paulo Bienal, 1955; Liturgical prize for woodcuts, Venice Biennale, 1960. ONE-ARTIST EXHIBITIONS: Bezalel National Museum, Jerusalem; Tel Aviv Museum, 1947; Artists' House, Jerusalem, 1957; Museum of Modern Art, Haifa, 1958; Bezalel National Museum, Jerusalem, 1962; Museum of Modern Art, Haifa, 1968; Pucker-Safrai Gallery, Boston, 1968; Maurice Spertus Museum of Judaica, Chicago, 1974; Engel Gallery, Jerusalem, 1977. MAJOR GROUP EXHIBITIONS: Der Sturm, Berlin, 1912; Berlin Secession, 1917; Tel Aviv Museum, 1945; São Paulo, Brazil, III Bienal, 1955; Bezalel National Museum, 1958; Israel Museum, 1965; Tel Aviv Museum, 1971; Museum of Modern Art, Haifa, 1973; Maurice Spertus Museum of Judaica, Chicago, 1974; Jewish Museum, New York, 1975; Tel Aviv University, 1978; Jerusalem City Museum, 1980. COLLECTIONS: Judah Magnes Museum; Hebrew Union College Skirball Museum; Judaica Museum of Greater Phoenix; Maurice Spertus Museum of Judaica, Chicago. REFERENCES: Kolb, Leon. *The Woodcuts of Jakob Steinhardt.* San Francisco: Filmer Bros. Press, 1959; Amishai-Maisels, Ziva. *Jakob Steinhardt Etchings and Lithographs.* Tel Aviv: Ziva Amishai-Maisels & Eli Bar-On, 1981; *Artists of Israel 1920-1980.* New York: The Jewish Museum, 1981; *Encyclopaedia Judaica.*

ALEC STERN Graphic artist, illustrator. b. 1904 United States. EDUCATION/TRAINING: California School of Fine Arts; Columbia University, teaching credential. PROFESSIONAL: Worked for advertising agencies and book publishers on both East and West coasts; eight years illustrator, *San Francisco Chronicle;* 1955 established own publishing plant, San Mateo, California. Published: *San Francisco Through the Years; Etchings of Israel—Land of the Bible; San Francisco Old and New,* and many booklets. COLLECTIONS: Metropolitan Museum of Art, New York; New York Public Library; Tel Aviv Hadassah Headquarters; Judah Magnes Museum. REFERENCES: Artist's file, Judah Magnes Museum.

HERMANN STRUCK Painter, graphic artist. b. 1876 Germany. d. 1944. Immigrated Palestine 1923. EDUCATION/TRAINING: Attended gymnasium and Berlin Academy. Studied Holland with Jozef Israels. Studied engraving studio of Hans Meyer. MEMBERSHIP: London Royal Society of Painters, Etchers and Engravers. TEACHING: Inspired Jewish graphic artists in Central and Eastern Europe, including Joseph Budko. EXHIBITIONS: Judah Magnes Museum, 1977; Hebrew Union College Skirball Museum, Los Angeles, 1976, 1981. COLLECTIONS: Judah Magnes Museum; Hebrew Union College Skirball Museum; Maurice Spertus Museum of Judaica, Chicago. REFERENCES: *From the Eastern Front.* Berkeley, Ca.: Judah Magnes Museum, 1977; Benezit.

# B I O G R A P H I E S

M O S H E   T A M I R   Painter, graphic artist, tapestry designer. b. 1924 Russia. Immigrated Palestine 1932. EDUCATION/TRAINING: Student of Mordecai Ardon; graduated Bezalel Academy of Arts and Design, Jerusalem, 1947; Accademia de Belle Arti, Rome, 1950-52. AWARDS: Struck Prize, Bezalel Academy of Arts and Design, 1947; Young Israeli Artists' Prize, 1949; Graphics Prize, VI Bienal, São Paulo, 1961. TEACHING: Bezalel Academy of Arts and Design, 1953-54; Institute for Painting and Sculpture, Tel Aviv; Associate Director, Bezalel, 1961; National Inspector of Art Education, Ministry of Culture and Education, Israel, 1963. EXHIBITIONS: One-artist, Artists' Houses, Jerusalem and Tel Aviv, 1952; Biennale, Venice, 1954; Galerie Breteau, Paris, one-artist, 1957; VI Bienal, São Paulo, 1961; Museum of Modern Art, Haifa, 1957; Stedelijk Museum, Amsterdam, 1958; Musée d'Art Moderne, Paris, 1958; Museum of Modern Art, Haifa, 1964; Beneth Gallery of Fine Art, Tel Aviv, 1969. COLLECTIONS: Israel Museum; Tel Aviv Museum; Haifa Museum; Victoria and Albert Museum, London; Amsterdam; New York; San Francisco; Judah Magnes Museum. REFERENCES: *Moshe Tamir.* Haifa: Museum of Modern Art, 1971; *Art Israel, 26 Painters and Sculptors.* New York: The Museum of Modern Art, 1964; Tammuz, Benjamin and Max Wykes-Joyce. *Art in Israel.* London: W. H. Allen, 1966.

A N N A   T I C H O   Graphic artist. b. 1894 Austria. d. 1980. Immigrated Palestine 1912. EDUCATION/TRAINING: Studied art Paris, London, Vienna, Amsterdam. AWARDS: Art prize, City of Jerusalem, 1965; Sandberg Prize, 1975; Israel Prize, 1980. ONE-ARTIST EXHIBITIONS: Stematsky Gallery, Jerusalem, 1934; Passedoit Gallery, New York, 1953; Bezalel National Museum, Jerusalem, 1959; Stedelijk Museum, Amsterdam, 1959; Baltimore Museum of Art, 1962; Museum of Modern Art, Haifa, 1962; Bezalel National Museum, 1963; Art Institute of Chicago, 1964; Museum Boymans van Beuningen, Rotterdam, 1964; Poses Institute of Fine Arts, Brandeis University, Waltham, Mass., 1967; Israel Museum, Jerusalem, 1968; Jewish Museum, New York, 1970; Ashmolean Museum of Art and Archaeology, Oxford, 1972; Israel Museum, 1973; Tel Aviv Museum, 1974; Israel Museum, 1978; Tel Aviv Museum, 1978; Israel Museum, memorial exhibition, 1981; Jewish Museum, New York, 1983. MAJOR GROUP EXHIBITIONS: Bezalel National Museum, 1958; American-Israel Cultural Foundation and the International Council of the Museum of Modern Art, New York, 1964; Israel Museum, 1965; Musée du Petit Palais, Paris, 1968; High Museum of Art, Atlanta, 1970; Tel Aviv Museum, 1971; Israel Museum, 1972; Maurice Spertus Museum of Judaica, Chicago, 1974; Jewish Museum, New York, 1976; Israel Museum, 1976; Illinois Bell, Chicago, 1978; Israel Museum, 1978; Los Angeles County Museum of Art, 1979; Jerusalem City Museum, 1980. COLLECTIONS: Reijksprentenkabinett and Stedelijk Museum, Amsterdam; British Museum, London; Museum of Modern Art, New York; Fogg Art Museum, Boston; Israel Museum, Jerusalem; Dizengoff Museum, Tel Aviv; Judah Magnes Museum; Boymans van Beuningen Museum, Rotterdam; Ashmolean Museum, Oxford; Art Institute of Chicago; Baltimore Museum of Art; Brandeis University; Tel Aviv Museum; Museum of Modern Art, Haifa. REFERENCES: *Artists of Israel 1920-1980.* New York: The Jewish Museum, 1981; *Anna Ticho Drawings.* Jerusalem: The Israel Museum, 1968.

# B  I  O  G  R  A  P  H  I  E  S

THEO TOBIASSE  Painter, graphic artist, sculptor. b. 1927 Israel. Immigrated Paris 1933. EDUCATION/TRAINING: École des Arts Décoratifs, Paris; Centre d'Art Dramatique, Paris. AWARDS: Dorothy Gould award from "La Jeune Peinture Méditerranenne"; Prix de Cassis. EXHIBITIONS: From 1962-70 did 12 one-artist shows throughout the world including three at Waddington Galleries, Montreal; two at Madden Gallery, London. Exhibited Switzerland, United States, England, Japan. COLLECTIONS: Paris, Nice, Geneva, Philadelphia, San Francisco, New York, Boston, Chicago, Los Angeles. Has been represented in the Salon de l'Imagerie since 1946; Judah Magnes Museum. REFERENCES: Artist's file, Judah Magnes Museum; Benezit.

LESSER URY  Painter, graphic artist. b. 1861 Prussia. d. 1931. EDUCATION/ TRAINING: Studied Anvers, Stuttgart, Dusseldorf, Brussels, Paris, and Italy. Influenced by French impressionists. EXHIBITIONS: Retrospective Berlin National Gallery, 1931; after World War II several shows in Germany; Glitzenstein Museum, Safed, Israel, 1968; Maurice Spertus Museum of Judaica, Chicago, 1983. COLLECTIONS: Musée de Gratz; Berlin; Görlitz; Judah Magnes Museum; Hebrew Union College Skirball Museum. REFERENCES: *Lesser Ury.* Berlin: Galerie Pels-Leusden; *Jewish Art: An Illustrated History;* Benezit.

LEE WAISLER  Painter, printmaker. b. 1938 United States. EDUCATION/ TRAINING: Self-taught. ILLUSTRATED: *Connections,* poems by Norman Rosten. ONE-ARTIST EXHIBITIONS: Ryder Gallery, Los Angeles, 1968-1971; Phyliss Lucas Gallery, New York; Welna Gallery, Chicago, 1972; Diogenes International, Athens; Lumley-Cazalet, London; Kunstsalon Wolfsberg, Zurich, Switzerland, 1973; Judah Magnes Museum, 1976; Prince Arthur Galleries, Toronto; Hooks-Epstein Galleries, Houston, 1978; Carl Schlosberg Fine Arts, Los Angeles, 1979; Downtown Gallery, Los Angeles, 1981. GROUP EXHIBITIONS: *Art and Survival,* Los Angeles; *The American Dream,* Los Angeles Contemporary Exhibitions; Brandeis University Library, Los Angeles; *Some Artists,* Security Pacific Plaza, Los Angeles; Albert Levin Gallery, Palm Springs; Boler Galerie, Paris; Brentanos, New York; Contemporary Gallery, Dallas; Dryden Gallery, North Carolina; Gilbert Galleries, San Francisco; Gimpel-Weitzenhoffer, Ltd., New York; Heritage Gallery, Oklahoma City; Lumley-Cazalet, London; Nouvelle Gravure, Paris; Randi's Art Gallery, Denver; Ryder Gallery, Los Angeles; Sam Stein Fine Arts, Ltd., Chicago. COLLECTIONS: Bibliothèque Nationale, Paris; Brooklyn Museum, New York; Coldwell Banker, Minneapolis; Cedars Sinai Collection, Los Angeles; Commercial National Bank, Kansas City, Missouri; Israeli Embassy, Paris; Jewish Museum, New York; Kunsthaus, Zurich; Judah Magnes Museum; Metropolitan Museum of Art; Security Pacific National Bank, Los Angeles; Standard Oil, Chicago; Stanford University Library, Palo Alto; Victoria and Albert Museum, London; William Rockhill Nelson Gallery, Kansas City, Missouri; Yale University Library, New Haven. REFERENCES: *Lee Waisler.* Berkeley: Judah Magnes Museum, 1976.

# B I O G R A P H I E S

A B R A H A M   W A L K O W I T Z   Painter, draftsman. b. 1878 Russia. d. 1965. Immigrated United States 1893. EDUCATION/TRAINING: National Academy of Design; Académie Julian, Paris, with Jean Paul Laurens. TEACHING: Educational Alliance, New York. AWARDS: American Academy of Arts and Letters, New York, Marjorie Peabody Waite Award, 1962. ONE-ARTIST EXHIBITIONS: "291," New York, 1912; Downtown Gallery, 1930; Park Gallery, New York, 1937; Brooklyn Museum, 1939; Newark Museum, 1941; New York Public Library, 1942; Schacht Gallery, New York, 1944; Chinese Gallery, New York, 1946; Charles Egan Gallery, 1947; Jewish Museum, New York, 1949; Wadsworth Atheneum, Hartford, 1950; ACA Gallery, 1955; Zabriskie Gallery, 1959, 1964, 1966, 1968, 1969, 1970, 1973, 1974; Danenberg Gallery, 1971. RETROSPECTIVE: Utah Museum of Fine Arts, Salt Lake City, 1974. GROUP EXHIBITIONS: National Academy of Design, 1904; Whitney Museum of American Art, New York; Armory Show, New York, 1913; Anderson Galleries, New York, Forum Exhibition, 1916. COLLECTIONS: Phillips Academy, Addison Gallery of American Art, Massachusetts; Museum of Fine Arts, Boston; Brooklyn Museum; Columbus Gallery of Fine Arts, Ohio; Kalamazoo Institute of Art; Library of Congress; Metropolitan Museum of Art, New York; Museum of Modern Art, New York; Newark Museum; Phillips Gallery, Washington, D.C.; Whitney Museum of American Art, New York; Judah Magnes Museum. REFERENCES: Lichtenstein, Isaac. *Jewish Artists Ghetto Motifs by Abraham Walkowitz.* New York: Machmadim Art Editions, Inc., 1946; *Dictionary of Contemporary American Artists.*

S T E P H A N I E   W E B E R   Artist of technology and mixed media works on paper. b. 1943 United States. EDUCATION/TRAINING: B.A., University of California at Los Angeles, 1963; University of Illinois, graduate studies, 1963-65. AWARDS: Los Angeles National Competition: chosen Outstanding Print, 1975, Purchase Prize, 1976, 1978; Boston National Print Competitions, Purchase Award, 1980, 1981. COMMISSIONS: City of Berkeley Commission, Centennial Poster; Judah Magnes Museum, Bicentennial Print; Brooklyn Museum Biennial, two prints, 1979. ONE-ARTIST EXHIBITIONS: Fine Arts Museum of San Francisco, 1976; William Sawyer Gallery, San Francisco, 1977; Palo Alto Cultural Center, 1978; Zara Gallery, San Francisco, 1978; Clark University, Massachusetts, 1980; De Saisset Museum, Santa Clara, California, 1981; Plum Gallery, Kensington, Maryland, and Georgetown, Washington, D.C., 1981; University of California, Davis, 1981; Texas Tech University, 1982; Amarillo Art Center, 1982; University of Dallas, 1982; Walnut Creek Civic Arts Gallery, 1982; Oakland Museum, 1982; Los Angeles Municipal Gallery, North Gallery, 1983; Laguna Beach Museum, 1983, Bank of America World Headquarters, San Francisco, 1983. GROUP AND INVITATIONAL EXHIBITIONS: Judah Magnes Museum, 1975; Mekler Gallery, Los Angeles, 1978; Palo Verdes Cultural Center, Los Angeles, 1979; Los Angeles Municipal, *Newcomers 77* and *Approaches to Xerography,* 1979; Fine Arts Museum of San Francisco, *New Acquisitions;* Oakland Museum, California, *New Acquisitions;* San Jose Museum, California, *Four Independents;* Richmond Art Center, California, *New Talent;* Artspace Gallery, Los Angeles; Center for the Visual Arts, Oakland, California; Judah Magnes Museum, Berkeley, California; Corcoran Gallery, Washington, D.C.; Cincinnati Museum, *California Graphics;* Alice Simpsar Gallery, Ann Arbor, Michigan; Exchange Exhibit, London, England; Brooklyn Museum, New York; George Eastman International Museum's Traveling Show, *Electroworks;* Newport Harbor Museum, California; Pratt Art Institute, New York, National Traveling Show, *California Light;* World Print Council, San Francisco, 1980; Helen Schlien Gallery, Boston, 1981;

# B I O G R A P H I E S

Library of Congress, *Art and Technology,* 1982; Seoul/San Francisco: *An Exchange of Prints and Drawings,* 1983. COLLECTIONS: Smithsonian Institution; Fine Arts Museums of San Francisco; Oakland Museum; Brooklyn Museum; University of California, Berkeley; Hayward, California, Hall of Justice; Brockton Art Center, Lexington, Massachusetts; Baltimore Museum; George Washington University; De Saisset Museum, University of Santa Clara; Judah Magnes Museum. REFERENCES: Artist's file, Judah Magnes Museum.

R U T H  W E I S B E R G  Printmaker, draftsman. b. 1942 United States. EDUCA-TION/TRAINING: Studied for ten years Junior School, Art Institute of Chicago. Studied Italy; received Laurea in painting and printmaking from l'Accadèmia de Belle Arti di Perugia. B.A. and M.A., University of Michigan; studied one year S. W. Hayter's Atelier 17, Paris. AWARDS: Ford Foundation Grant, 1969-70. BOOKS PUBLISHED: *Tom O'Bedlam's Song; The Shtetl, A Journey and a Memorial.* TEACHING/PROFESSIONAL: Since 1979 Associate Professor and Associate Dean, University of Southern California; since 1970 Director, Kelyn Press, Venice, California. COMMISSIONS: University Synagogue, Los Angeles; Women's American O.R.T., Districts 8 and 11; Graphic Arts Council, Los Angeles County Museum of Art. ONE- AND TWO-ARTIST EXHIBITIONS: Pollack Gallery, Toronto, 1969, 1971; University of Southern California, University Galleries, Los Angeles, 1972; University of California, Santa Barbara, Center for Creative Studies, 1972; Seaberg/Isthmus Gallery, Chicago, 1972; Municipal Art Gallery, Oslo, 1972; Triad Gallery, Los Angeles, 1974; Richard Nash Gallery, Seattle, 1971, 1972, 1974; Norwegian Graphic Arts Association, Oslo, 1975; ADI Gallery, San Francisco, 1975; Palos Verdes Art Center, Rancho Palos Verdes, California, 1976; Memorial Union Gallery, Arizona State University, Tempe, 1976; University of Texas, Dallas, 1977; Oglethorpe University, Atlanta, 1977; El Camino College, Los Angeles, 1977; Alice Simsar Gallery, Ann Arbor, Michigan, 1966, 1968, 1969, 1972, 1974, 1977; Space Gallery, Los Angeles, 1978; Santa Barbara City College, 1978; Hunter Arts Gallery, Hunter College, New York, 1978; Spencer Museum of Art, University of Kansas, Lawrence, 1979; Los Angeles Municipal Art Gallery, Barnsdall Park, 1979; Peppers Art Gallery, University of Redlands, California, 1980. GROUP EXHIBI-TIONS: Detroit Institute of Art, 1969; American Academy of Arts and Letters, New York, 1969; International Biennale of Graphic Art, Fredrikstad, Norway, 1972, 1974; International Biennale of Graphic Art, Segovia, Spain, 1974; American Embassy, Ankara, Ismir and Istanbul, Turkey, 1975; Contemporary Graphics Center, Santa Barbara Museum of Art, 1975; Indianapolis Museum of Art, Indianapolis, 1975; Malaspina Printmakers Society, Vancouver Art Gallery, 1975; California State University, San Diego, 1976; Fine Arts Museums of San Francisco, 1976; National Invitational Women's Building, Los Angeles, and National Women's Year Conference, Houston, 1977; National Museum of Modern Art, Seoul, Korea, 1978; Downey Museum of Art, Downey, California, and Citrus Community College Art Gallery, 1978; Art Institute of Chicago, 1978; Space Gallery, Los Angeles, 1978; E. B. Crocker Art Museum, Sacramento, 1978-79; Judah Magnes Museum, 1979; Contemporary Arts Center, New Orleans, 1980; Pratt Graphic Center, New York, 1980. COL-LECTIONS: Achenbach Foundation for Graphic Arts, Fine Arts Museums of San Francisco; Art Institute of Chicago; Bibliothèque Nationale de France, Paris; Dance Collection, New York Public Library, Lincoln Center, New York; Detroit Institute of Art; Eastern Michigan University, Ypsilanti; Grand Rapids Museum of Art, Michigan; Hebrew Union College, Cincinnati; Houghton Library, Harvard University; Indianapolis Museum of Art; Jewish Museum, New York; Judah Magnes Museum; Los Angeles County Museum of Art;

# B I O G R A P H I E S

Massachusetts College of Art, Boston; Maurice Spertus Museum of Judaica, Chicago; National Museum of Norway, Oslo; New York Public Library; Oslo Municipal Collection, Oslo; Hebrew Union College Skirball Museum, Los Angeles; Tronheim Municipal Museum, Norway; University of Michigan Museum of Art, Ann Arbor; University of Michigan Rare Book Collection, Ann Arbor; University of North Dakota, Grand Forks; University of Southern California, Los Angeles; University of Texas Rare Book Library, Austin; William Andrew Clark Library, University of California, Los Angeles; Y.I.V.O., The Institute of Yiddish Research, New York. REFERENCES: *Ruth Weisberg*. Berkeley: Judah Magnes Museum, 1981.

BERNARD BARUCH ZAKHEIM   Painter, watercolorist, muralist, sculptor. b. 1898 Poland. Immigrated U.S. 1920. EDUCATION/TRAINING: Applied Art School, Warsaw Academy of Poland; Kunst Gewerbe Schule, Munich; Politechnicum, Danzig; School of Fine Arts (Mark Hopkins), San Francisco. Student of Enrico Glicenstein, Poland; worked with Diego Rivera, Mexico, 1930. AWARDS: First award, San Francisco Art Association, Artist Purchase Prize, 1941; First Prize, Artrium, Santa Rosa, 1968 (for wood sculpture); Huntington Hartford Foundation Fellowship, Pacific Palisades, California, 1963. PROFESSIONAL: Six large wood sculptures, a monument of the Warsaw Ghetto uprising, purchased by Mount Sinai Memorial Park, Los Angeles, 1969. HISTORICAL MURALS: Coit Memorial Tower Fresco, 1933; Alemany Health Center, two frescoes, 1934; University of California Medical School, Cole Hall, San Francisco, two frescoes; University of California Hospital, Toland Hall, ten frescoes, 1934-38; Jewish Community Center, San Francisco, one fresco and mosaic fountain, 1932. ONE-ARTIST EXHIBITIONS: University of California School of Medicine, San Francisco, 1968; Judah Magnes Museum, 1973; University of California, San Francisco, Millberry Union, 1973; Jewish Community Center, 1973; Sonoma State College, Rohnert Park, California, 1973; *Ghetto Wall*, commemorating 25th anniversary of Warsaw Ghetto's uprising against Nazis, Judah Magnes Museum, 1968. GROUP EXHIBITIONS: Annually with San Francisco Art Association; World's Fair, New York; World's Fair, Golden Gate Exposition, San Francisco. COLLECTIONS: San Francisco Museum of Art; Jewish Historical Institute, Warsaw; Brandeis University; Mickiewicz Museum, Warsaw; Oakland Museum; Judah Magnes Museum. REFERENCES: Artist's file, Judah Magnes Museum.

THE JUDAH L. MAGNES MUSEUM collects, preserves, and exhibits artistic, historical, and literary materials illustrating Jewish life and cultural contributions throughout history. The Museum is a major archive for historical documents of Jewry of the Western United States and assists in the preservation of Jewish cemeteries of the Gold Rush era. Established in 1962, the Magnes became the first Jewish museum in the United States to be accredited by the American Association of Museums.

## Staff

Seymour Fromer, *Director*
Ruth Eis, *Curator*
Alice Perlman, *Assistant Curator*
Florence Helzel, *Assistant Curator, Prints and Drawings*
Ted A. Greenberg, *Registrar*
Malka Weitman, *Public Relations*
William Chayes, *Exhibition Designer*
Jane Levy, *Librarian*
Arlene Sarver, *Order Department*
Sara Glaser, *Reception*

# WESTERN JEWISH HISTORY CENTER

### Advisory Committee

Norman Coliver, *Chairman*
Frank H. Sloss
Harold Edelstein
James M. Gerstley
Douglas E. Goldman
James D. Hart
Louis H. Heilbron
Phillip E. Lilienthal
Elinor Mandelson
Robert E. Sinton
Daniel E. Stone
Alma Wahrhaftig
Sue Rayner Warburg
Seymour Fromer, *Secretary*

### Staff

Moses Rischin, *Director*
Ruth Rafael, *Archivist*
Lynn Fonfa, *Assistant Archivist*
Elaine Dorfman, *Oral History Director*

*Design:*  *Gordon Chun Design*

*Typography:*  *The Type Cycle*

*Printing:*  *Concept Enterprises*

*Editor:*  *Deborah Kirshman*